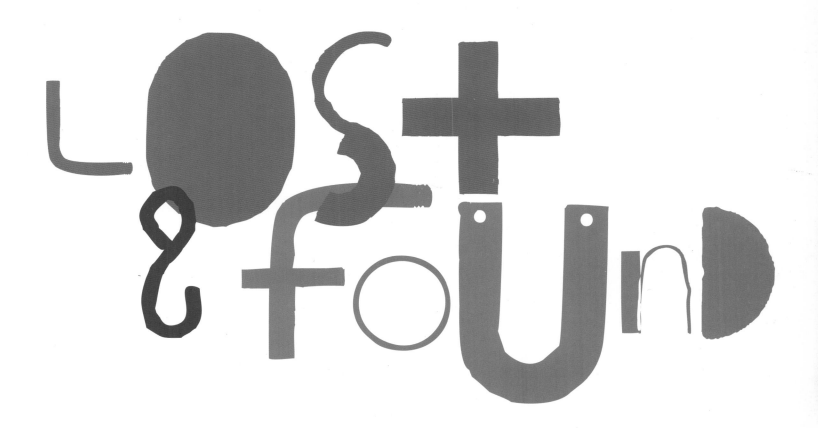

LOST & FOUND

critical voices in new British design

Birkhäuser: Basel · Boston · Berlin | The British Council

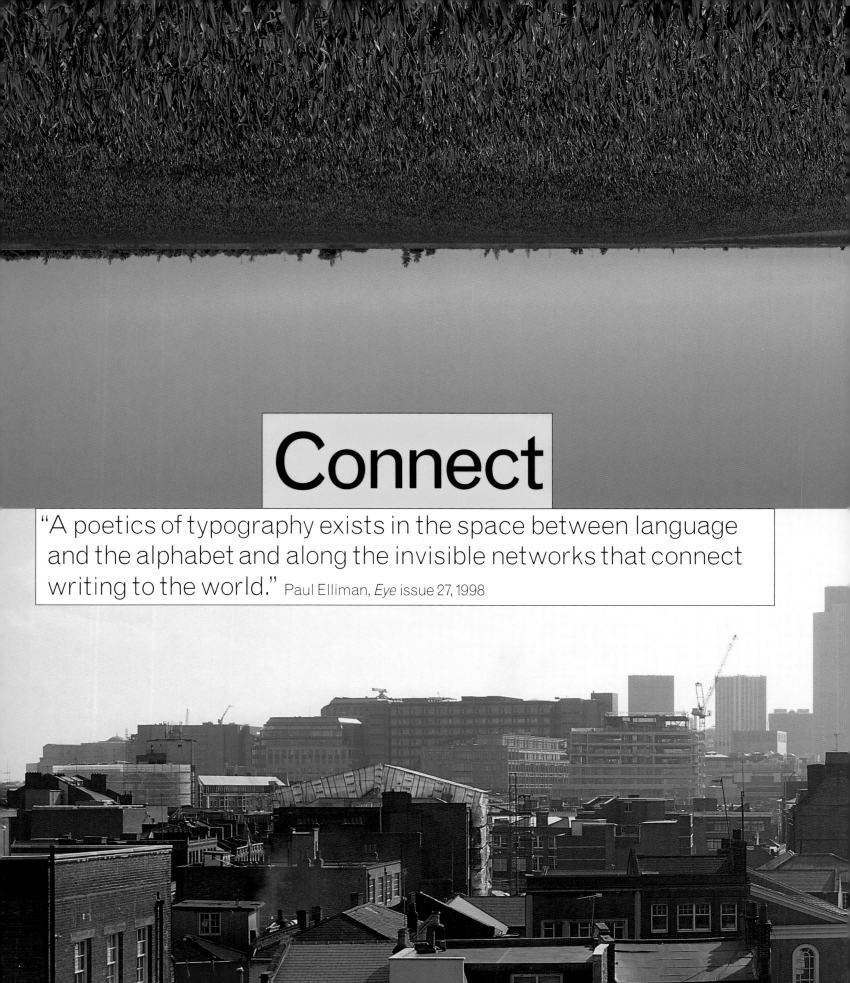

Connect

"A poetics of typography exists in the space between language and the alphabet and along the invisible networks that connect writing to the world." Paul Elliman, *Eye* issue 27, 1998

Intensify

"[I'm] reducing things down to focus the message ...trying to enhance the specific experience by removing anything that does not directly participate in it." Nick Bell

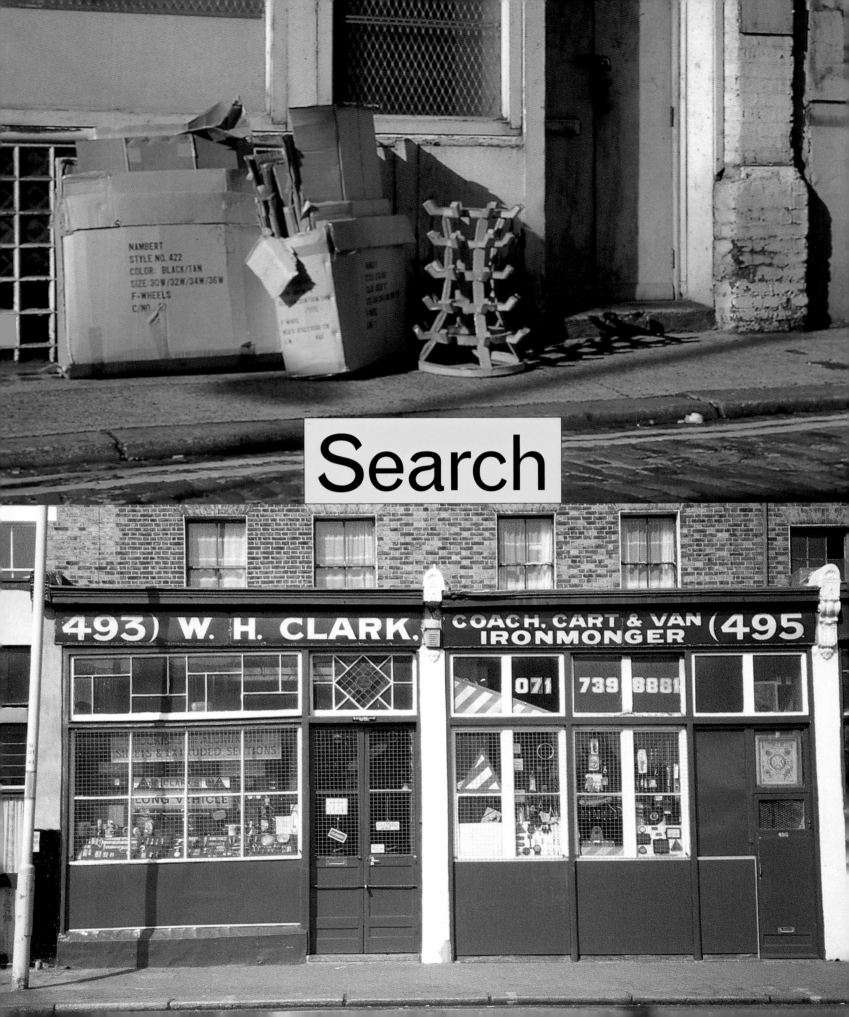

Search

"After a century of mass overproduction, terms like found object, or the exquisitely defined *objet trouvé*, are obsolete. Whoever first said 'readymade' was very clever, but it's a long time since people discovered that you could dig with an antler – something serviceable, heraldic and mythic all rolled into one. Humans don't change that much." Richard Wentworth, *Thinking Aloud*, 1999

Opposite top: Neil Cummings
Readymade Returned, 1995
A remake of Marcel Duchamp's original 'found' bottlerack from waste cardboard
Photo: Neil Cummings

Opposite bottom: W. H. Clark, ironmongers. Designer Michael Marriott scoured east London hardware stores to produce his 'Bucket light' (see p73)
Photo: Michael Marriott

Above: Richard Wentworth, part of Parade: Twenty One Non Sequiturs, *Reading Things* publ. Chance Books, 1993

OASIS CUPID ROMANCE HORIZON

 NECTAR PARTHENON ARIEL TOUCHSTONE

PALADIN TUNDRA BOHEMIA SUMMER

 POLESTAR MANDALAY RIVULET AVALON

CELESTE RUBICON MOONBEAM MOUNTAINMIST

 ARCHANGEL EMPRESS SERENADE OLYMPUS

ANGEL SONATA ARGOSY MIDAS

 NEPTUNE PANDORA RHAPSODY STARDUST

POMPEII ZEPHYR QUICKSILVER ATLANTIS

 INTERLUDE GLADE VENUS ENCHANTMENT

SAHARA ELDORADO BALM TAHITI

 ARABESQUE ISIS WATERFALL WHISPER

"I can't help feeling disappointed about what's happening in furniture design now. Too much is made that is transitory, and is designed and made for all the wrong reasons. Advertising and magazines are breeding a culture of discontent. People are made to feel that they must have something new and different for its own sake. To produce things which are merely new and not better is really evilThings should be made because they are better and with regard to the limited resources of the planet, so they should be reusable and long-lasting. But the main drive in magazines and on television – in those awful programmes about interior design – is for impermanence. People often think that mere newness is innovation, but it isn't." Robin Day, *Guardian*, 13 March 1999

Good/Bad

"The lack of critical commentary in design and design history has produced an ambivalence toward language. Writing about design sometimes seems pointless or suspect, and design as the expression of the written language has been seen as a less than artistic pursuit. Design becomes the composition of purely pictorial elements rather than the manipulation of both text and language." Good History/Bad History, Tibor Kalman, *Print* magazine, March/April 1991

Graham Gussin, 1994,
design for a wallpaper.
Text taken from Dulux
emulsion paint names.
Courtesy Peter Langley

"Face Recognition will match known 'target faces' by using our existing CCTV network. Images received at the Council's Security Control Centre will undergo automatic comparison with a library of target faces supplied to us by the police...

The system will be able to identify these faces from crowds of people and Security Officers will be alerted when a target appears on a CCTV screen. Once the operator has manually identified a target, the information will then be passed on to the police for them to take action if appropriate....

Councillor Ian Corbett, said: 'Face Recognition will build on Newham's success in seeing crime slashed in the borough by pioneering new CCTV techniques. This is the first time that 'Faceit', Face Recognition has been used in the UK.... The new scheme will help make Newham a safer place for all who live, work and visit the borough." Press release, London Borough of Newham, October 1998

Survey

MUSIC OR PUBLIC ADDRESS SPEAKER

TV

ROOM AUDIO

RADIO

INTERCOM

NORMAL SPEAKER LEADS CONNECTED TO AMPLIFIER IN LISTENING POST

ROOM AUDIO REPRODUCED AT EAVESDROPPER LISTENING POST

TARGET PREMISES ← → LISTENING POST

Heissner's Coloured Garden Figures (Foreign.)
Artistically Designed. Hand Painted. Weather Proof.

No. 228.
Miniature Gnomes. Set of six, 8 in. high, 2/6 each, 15/– set

Identify

"The other [project] was a scheme for entirely abolishing all Words whatsoever.... Many of the most Learned and Wise adhere to the new scheme of expressing themselves by *Things*; which have only this inconvenience attending to it; that if a Man's Business be very great, and of various kinds, he must be obliged in Proportion to carry a greater Bundle of *Things* upon his back...."
Jonathan Swift, *Gulliver's Travels*, 1726

"Shopping is an activity that consists of predictable yet indeterminate activities, where, as in the cinema, what we experience over and over again is our own desire."
Rem Koolhaas, *S,M,L,XL*, 1996

Opposite: Illustration
from *Wiretapping and
Electronic Surveillance:
Commission Studies*
published by Loompanics
Unlimited.

Lisbon

Bilbao

Agen

Venice

Inti

Hamburg

Berlin

Shanghai

Copenhagen

Paris

mate

New York

Salzburg

IDEO's 'Kiss Communicator'
uses technology to reproduce
a human kiss and digitally
transmit it to a receiver
device in another part of the
world. Kiss: Alex Stetter

Overleaf:
The American Air Museum
in Britain, Duxford. Architect:
Sir Norman Foster, 1997.
Photo: Nigel Young

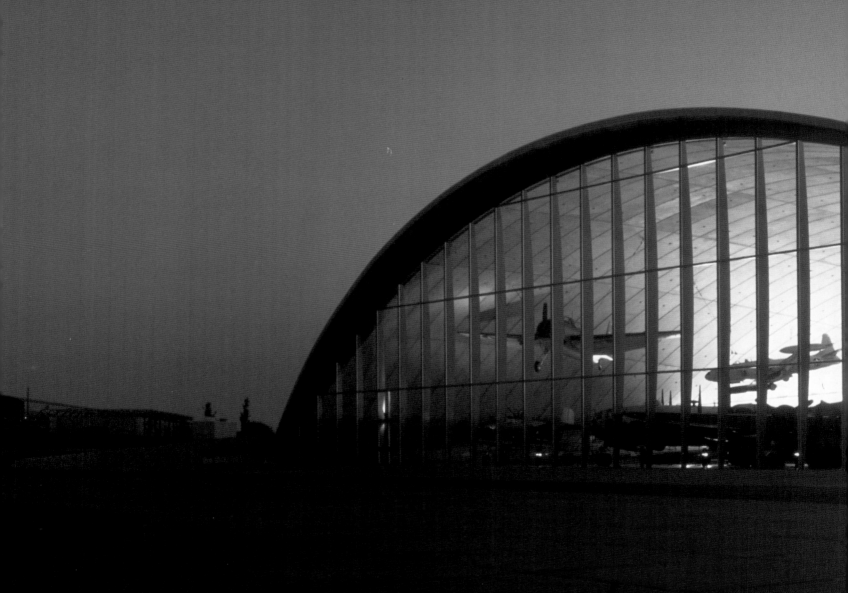

"Nostalgia is

unthinkable."

"Syntheses can also be constructed from the distance and differences between the constituent points, and not only by the old idealistic method of organic unification."

Frederic Jameson, *London Review of Books*, 18:24, 1996

"The challenge is to blur the boundaries between the real and the fictional so that the conceptual becomes more real and the real is seen as just one limited possibility."

Tony Dunne, *Blueprint* magazine, November, 1988

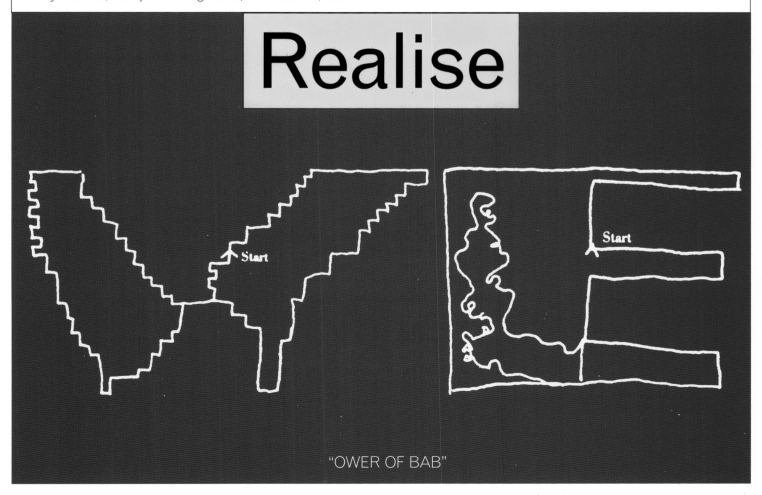

Realise

"OWER OF BAB"

Lost and found
Preface

This exhibition features 38 British designers whose work provokes fundamental questions about the nature and role of design in Britain today. In the texts that follow, Rick Poynor, who writes specifically about graphic design, talks about a generation which has little sympathy for the conventional wisdom that designers should serve their clients 'with professional neutrality and no discernible point of view'. Marcus Field, one of the selectors of the furniture and products for the exhibition, calls the environment in which these designers are working 'a new culture of contemplation', a climate in which they consider the past as well as the future, and in doing so notice that what was once held to be a dominant truth of Modernism ('the formal order of objects') is only a partial truth after all.

Through the work selected for this exhibition, from across the fields of furniture and product design, fashion and graphics, the selectors look at the way design is being redefined as an activity with a content and meaning of its own. The method, common to nearly all the chosen designers, is not to take the route of finding ever more elegant and efficient solutions to the problems of manufacturing industry, but to search about among the myriad products, materials, processes, signs, symbols and manufacturing techniques already in existence and reconstitute them in striking new forms. The results are perhaps best described as a sort of urban poetry, in which wit and social observation (particularly in relation to consumer wastefulness) are held in a fine balance.

The title, *Lost and Found*, refers to the vast repository of goods and materials surviving without particular purpose in post-industrial Britain, just as a Lost Property Office (or Lost and Found) is an accumulation of random objects separated from their owners. The streets of Britain – London in particular – have played no small part in furnishing ideas and materials for some of Britain's most significant artists over the past two decades – Rachel Whiteread, Bill Woodrow and Richard Deacon among them – and one of the themes which this exhibition explores is the way in which the old dividing lines between art, design, fashion, music, architecture, food (ref. Damien Hirst's restaurants), clubbing, marketing and high and low culture are dissolving into one another. Through the use of accompanying film, sound, photographs and objects, the exhibition attempts to provide a context for the work on view, not only to give something of the texture of life in Britain but to illustrate some of the personal histories and tastes of the selected designers, which in turn feed their originality and individuality. This is inclusive design, uninterested in pursuing the sleekness and exclusivity which characterises much design philosophy; but interested in exploring and experimenting with contemporary culture at all levels, whether old and new, flawed or fabulous.

The exhibition has been substantially shaped and guided by the involvement of our original partners in Frankfurt, Hornu and Bordeaux; the contributions made by James Bradburne, Director and Volker Fischer, Curator of the Museum fur Kunsthandwerk, Françoise Busine, Director of Grand Hornu Images, and Francine Fort, Director and Michel Jacques, Curator of Arc-en-Rêve Centre d'Architecture have been central to the development of the project.

We should like to thank Nick Barley, Stephen Coates and Marcus Field who together have devised the concept for the exhibition and taken overall responsibility for the selection of designers and their work. Nick Barley (with contributions from Jessica Lack, Alex Stetter and Stephen Coates) has written the biographies of the selected designers in this publication and Marcus Field the text on furniture and product design. We should also like to thank Caroline Roux who, together with Suzanne Lee, has curated the fashion section of the exhibition; Stephen Coates, who has curated the section on graphic design as well as designing this book in partnership with Anne Odling-Smee; Rick Poynor, who has written so perceptively on graphic design; Caroline Evans who wrote the essay that follows on British fashion designers; and Volker Fischer, who has written about British design from the vantage point of the European mainland. We should also like to extend our thanks to our patient co-publisher, Robert Steiger of Birkhäuser.

An exhibition of this nature could not be realised without the help of a large number of people, and we would particularly like to thank Victoria Thornton, adviser to the British Council on architecture, and Helen Tsoi for the project management. We should like to thank the architectural practice muf, who have designed the show and, true to the spirit of the enterprise, brought something uniquely theirs to it in the process. In London, Brett Rogers, Head of Exhibitions at the British Council, has been responsible for overseeing the organisation of the exhibition from the outset; and Caroline Douglas, Exhibition Officer, has seen the exhibition through to its fruition, with the help of Lizzie Carey-Thomas and Andrew Gwilliams. We should also like to thank Elke Ritt of the British Council in Cologne, Catherine Ferbos-Nakov at the British Council in Paris, and Andrea Addison at the British Council in Brussels who have all brought their customary enthusiasm to the preparation of the exhibition, as well as their support.

Andrea Rose, Director, Visual Arts
The British Council

Lost and found
Introduction

Design has lost its innocence. A century of radical changes has seen to that, and today's designers find themselves in a world which no longer believes it can solve all the problems it has created. Their forefathers, the draughtsmen and engineers of the early part of the century who dutifully and often anonymously shaped buses, road signs and letter boxes, offered a simple service for their bosses. The modernist designers who came afterwards, emphasising the subservience of form to function (in the name of high quality mass production) and dominating the culture of design for the best part of fifty years, have also been superseded.

In their place, a new breed of designers has emerged in Britain whose work celebrates ideas. Like the conceptual artists who made a virtue of ideas in contrast to the materialists of the Modern movement, the new wave of designers start with concepts or questions. How can we best make use of advances in technology when we are already surrounded by noise pollution? What is the role of the product designer in a world already dogged by over-production? And how can designers play a responsible role in using the earth's scant resources?

The new approach to design is typified by the work of designers from many disciplines featured in this book. It is a critical approach, characterised by the articulation of the designer's own point of view in his or her work. Modernism was born out of a sense of social responsibility too, where the role of design was thought to be to bring the best possible products to the masses at the lowest price. However, the points of view made explicit in *Lost and Found* are much more diverse and often a good deal more cynical. They range from

political anger to ambivalence about technology; but they are united by the conviction that there is no simple, utopian solution to Britain's social and political problems. Instead, designers have understood that by applying their minds to these social and cultural questions, they can play a part not only in shaping products for today's consumers, but also in defining the kind of products we may need in the future. The new approach to design is characterised by resourcefulness, by multiculturalism and by humour. Above all, it is a culture of criticism; a culture of ideas.

Resourceful design

In 1962 the American designer Victor Papanek created a radio needing no batteries or current, consisting of an old tin can full of wax and a wick which burnt in order to provide power for a transistor and a small earpiece. Papanek's ideas were ridiculed by the American design profession, and he became known by many of his colleagues as "the Garbage Can Designer".

We have been living for many years with the same concerns that Victor Papanek was discovering before the 1970s oil crisis, but recently there has been a change of mood. Only over the past five years has the idea of a resourceful, responsible approach to design entered the mainstream, with international manufacturers making real efforts to include components in mass produced objects which are either recycled (such as old car components) or sensibly sourced (such as hemp for creating breeze blocks for building). *Lost and Found* features a number of designers who have made resourceful design a central part of their project.

The idea of using found objects or appropriating ones originally intended for another use is becoming increasingly common in Britain, but this is balanced by a powerful drive to create products which are also aesthetically pleasing (a concern which Victor Papanek seems to have relegated to a remote second place). Moreover, the designer's own personal motivations (as opposed to those of the client) are becoming increasingly overt, and often this extends to the legitimate

Right: Radio designed in 1962 by Victor Papanek with George Seegers, a student at North Carolina State College. It is made from a used tin can filled with parafin wax. When burned, the heat provides enough energy to power a radio receiver
Opposite: Every resourceful designer's first port of call? The Slingsby catalogue brings together anonymous designed objects for the workplace in a parallel universe where style is seemingly irrelevant

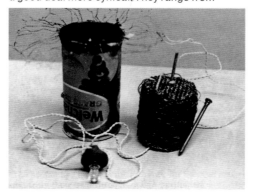

HEAVY DUTY PVC GAUNTLET

- 10.5" PVC gauntlet.
- Ideal for chemical and mechanical protection.
- Colour: Red.
- Supplied in a box of 12 pairs.
- Sizes: 8,9. *Please specify size of glove required.*

Design No. LP41 **Price £56.51 per box.**

HEAVY DUTY PVC GAUNTLET

- 16" PVC gauntlet.
- Ideal for chemical and mechanical protection.
- Colour: Red.
- Supplied in a box of 12 pairs.
- Sizes: 8,9. *Please specify size of glove required.*

Design No. LP44 **Price £82.78 per box.**

HEAVY DUTY PVC GAUNTLET

- 22" PVC gauntlet.
- Ideal for chemical and mechanical protection.
- Colour: Red.
- Supplied in a box of 12 pairs.
- Size: 8 only.

Design No. LP46 **Price £131.14 per box.**

10.5" NATURAL RUBBER GAUNTLET

- Manufactured to BS1651 (1986).
- Protects against liquids, alkalis, aldehydes and salts.
- Available in medium or heavy duty. • Supplied in a box of 12 pairs.
- Sizes: 8, 9, 10, 11. *Please specify size of glove required.*

Design No. RG101 – Medium duty **Price £48.22 per box.**
Design No. RG102 – Heavy Duty **Price £57.67 per box.**

17" NATURAL RUBBER GAUNTLET

- Manufactured to BS1651 (1986).
- Protects against liquids, alkalis, aldehydes and salts.
- Available in medium or heavy duty. • Supplied in a box of 12 pairs.
- Sizes: 8, 9, 10, 11. *Please specify size of glove required.*

Design No. RG104 – Medium Duty **Price £71.93 per box.**
Design No. RG105 – Heavy Duty **Price £83.79 per box.**

24" NATURAL RUBBER GAUNTLET

- Manufactured to BS1651 (1986).
- Protects against liquids, alkalis, aldehydes and salts.
- Available in medium or heavy duty. • Supplied in a box of 12 pairs.
- Sizes: 9, 10, 11. *Please specify size of glove required.*

Design No. RG107 – Medium Duty **Price £118.75 per box.**
Design No. RG108 – Heavy Duty **Price £136.43 per box.**

SATURN™

- High visibility glove with a fluorescent vinyl coating and insulated liner.
- Resistant to grease, oil, dirt and grime.
- Extra long knit wrist for added comfort.

- Size: XL only. • Length: 300mm. • Thickness: 2.8mm.
- Supplied in a box of 12 pairs.

Design No. RGHSN **Price £63.76 per box.**

NITRON™

- Heavy duty Nitrile coated glove with a cotton jersey lining.
- Ideal for handling rough materials.
- Offers excellent resistance to abrasion, cuts, punctures, grease and oil.

- Available with or without a safety cuff. • Supplied in a box of 12 pairs. • Size: Large only. • Length: 260mm. • Thickness: 1.4mm.

Design No. RG940 – Without safety cuff. **Price £43.86 per box.**
Design No. RG960 – With safety cuff...... **Price £48.30 per box.**

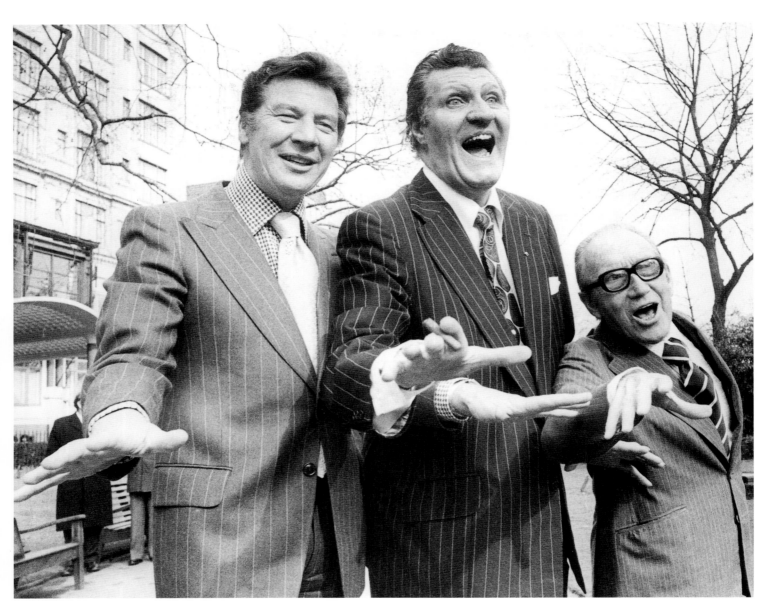

questioning of what exactly the nature of an object's function should be. Design-aware clients are commissioning designers whose critical approach to the project will form an important part of their response to the brief – a role which the client expects as part of the design solution. Increasingly, companies (the Parisian haute couture establishments Dior and Givenchy are the most internationally renowned) employ designers precisely because of their own authorial approach, which in itself has become the most important feature of the design. It is a far cry from functionalism.

Multiculturalism

The British design community is populated to a large extent by designers from overseas. Many of them have come to London in order to study, often at the Royal College of Art or at Central St Martins College of Art and Design, and then stayed in town after completing their studies. Conversely, many home-grown designers spend time abroad and then return to Britain with a very different perspective. The extraordinary trading of cultures has had a powerful impact, and the influence of Japanese, Italian, American, Cypriot, Spanish, Austrian,

German and British, as well as countless other cultures is clearly evident in the work of designers featured in *Lost and Found*.

Humour

The British heritage of stand-up comedy, typified by television heroes like Morecambe and Wise, and Tommy Cooper, resonates in many of the design projects in *Lost and Found*. Equally, Spanish cartoons and Japanese Manga comics have influenced the work of designers, whose work has an irreverent streak which would have bemused many of the modernists. The legacy of punk culture and the kitsch suburban design interventions of the post-war era, have proved irresistible to designers with a taste for irony and knowing quotations.

Cross-disciplinary dialogue

Design, and the (often woefully under-theorised) criticism which accompanies it, has traditionally remained resolutely within professional disciplines: magazines such as *Blueprint*, which explores cultural issues common to all designers, are few and far between. Equally, design exhibitions have tended to exclude disciplines such as fashion, preferring to tread the safe home ground of 3D design or graphics (there has never been a major exhibition at London's Design Museum devoted to fashion design, for example). Generalist design exhibitions such as Powerhouse::UK and Jam at the Barbican Art Gallery, appeared to set out with the over-simplistic thesis that British design in general is spiritually in tune with popular street culture.

Fashion designers on the other hand, have no need to look to graphics or 3D design: their needs are served by the twice-yearly catwalk shows in London, Paris, New York and Milan which in turn feed the acres of hagiographic press coverage all over the world. Fashion theory, limited to a small number of organisations such as the Fashion Institute of Technology in New York and its journal *Fashion Theory*, has tended during the last twenty years to draw on the language of art criticism, rather than design history. Analysis became significantly more sophisticated with Roland Barthes' 1967 book *The Fashion System* (which attempted to interpret fashion through the

interrogation of phrases from fashion magazines, such as "gingham, for the weekend, for the vacation, and for the whole family"), but comparisons and parallels with the work of designers from other disciplines has remained limited.[1]

In this book we aim to illustrate that there are important intellectual parallels between the design disciplines. From fashion designers and product designers to graphic designers and furniture designers; even architects such as muf – the designers of the *Lost and Found* exhibition – all are drawing inspiration from similarly diverse sources: history; philosophy; contemporary art; popular culture; music; literary theory; politics. In its extraordinary breadth as well as its equal relevance across the disciplines, it is a range of sources that designers working in the 1920s could not have dreamt of.

Design is a broad church and we are not suggesting that the designers in *Lost and Found* all speak with the same voice; in fact, some vehemently disagree with one another. Nevertheless, the sensibility I have described here is not a matter of coincidence, and taken together, these critical voices add up to more than the sum of their parts. In the words of the writer Frederic Jameson, "Syntheses can also be constructed from the distance and differences between the constituent points, and not only by the old, idealistic method of organic unification."[2] In this sense, the approaches featured here add up to a design movement.

Lost and Found

It has become essential to conceive of design as going beyond simply a service to clients. Design is now being seen as a way of communicating personal and political messages; as a means for exploring intellectual, cultural and social questions; as a means for changing attitudes and behaviour. If the approach of the draughtsmen and engineers of the early-20th century has been lost, this book explores the rich seam of ideas that contemporary designers have found to replace it.

1. See Sung Bok Kim's analysis in *Fashion Theory*, March 1998)
2. *London Review of Books*, 18:24, 1996

Volker Fischer

Character, charisma and common sense

Britain in the context of European design

At the turn of the century British design is once again attracting as much international attention as London's "swinging sixties" did 35 years ago. In Europe's specialist journals, such as *Domus* and *Abitare*, *ARDI* and *On Disegno*, *Form* and *Design Report*, *Art und Ambiente* or *Cree*, a renewed Anglophilia is catching on which reduces the Britishness in product and graphic design, music and fashion, architecture and interior design, art and theatre to the marketable labels of Britpack, Britart and Britpop. Each time the focus is on 25 to 35 year old designers and artists and pushed to the fore is a new, young counter-culture which is orientated towards the models and postures of the pop scene and advertising, combining and gratifying the opposing worlds of the avantgarde and the in-people.

In October 1996 the German interior design magazine *Architektur und Wohnen* presented its first ever special issue on London, no longer the secret capital of European visual culture. Fashionable restaurants and bars, features on architects and designers, shops and flea markets were presented as an attractive mixture for tourists. The cover is graced by Tower Bridge and the Thames, in which float the pop-coloured, blown-up design objects of the group Inflate, who since then have been preparing to compete on the Continent with Alessi's plastic conversation pieces as well as the matt-coloured plastic cups and cutlery by Authentics. In the issue the discussion centres on the "swinging nineties", a non-stop party in London, the city as the "password to a virtual realm" and of the alternative "Chippendale or post-punk". Such a piecemeal view is undoubtedly the result of transposing the MTV aesthetic of the fast video clip onto widespread cultural developments and considers these each time as just the latest trends and changes on the scene. If only superficially, there are now in fact a number of staggering parallels with the sixties, even if the context and cultural references have changed.

The scene for the coolest trend-setters has shifted from the utopian and hippy charms of Carnaby Street and Portobello Road to interior spaces, most obviously into the new designer restaurants like Belgo by Ron Arad, Wagamama by John Pawson, Terence Conran's restaurants Mezzo and Bibendum or Marc Newson's Coast. The super-slim model, Twiggy, has acquired numerous 90s followers, from the worlds of sport, film and music. Whether Madonna or Marianne Faithfull for Jean-Paul Gaultier and Lainey Keogh, English footballers for Cerruti and Armani, the film star Patsy Kensit for Ben de Lisi and Valentino, John Malkovich for Comme des Garçons, or Jade Jagger for Matthew Williamson – all of them are exhibiting the end-of-the-century attitude that modelling is much more than the representation of clothes: "The only thing that counts is pure surface". And designers are also expected to be smart, a dozen or so, for example, Ron Arad and Tom Dixon, Ross Lovegrove, Marc Newson or Jasper Morrison are being marketed as pop stars just as Cliff Richard, Rod Stewart or Mick Jagger were at one time.

A typically English rudeness, hand in hand with a morbid sense of humour and surreal shock tactics, still continues in art and the theatre. The "Britpack" artists that were supported by Charles Saatchi – Damien Hirst, Rachel Whiteread and Sarah Lucas, for example – could be considered the children of Lucian Freud and Francis Bacon. The advertising tycoon has already set out to establish yet another new movement, the so-called "neurotic realism". Plays by young writers such as Mark Ravenhill ("Shopping and Fucking") and the late Sarah Kane ("Blasted") are hits in theatre programmes on the Continent precisely because of their gritty, urban, state-of-the-nation themes, and stand in the tradition of plays from the 60s like Edward Bond's anti-Vietnam work "The War Plays".

Bands like Take That, the Spice Girls or Boyzone have replaced the catchy beat rhythms of the Beatles era with disco music. The former counter-culture of the Rolling Stone's "Streetfighting Man" and Pink Floyd's "We don't need no education" is being watered down into anodyne slogans. Salman Rushdie's poetry is used in the latest single by U2, forming a crazy combination. The vibrant posters and amoeba-like typefaces of the 60s appear naive now thanks to the extensive graphics software of modern desk-top publishing and in comparison to the ragged typography that Neville Brody developed in the 80s for

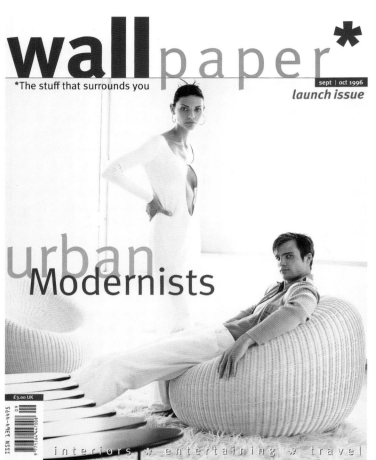

The ultimate triumph of ironic style over glitzy content, *Wallpaper** nevertheless seduced a generation for whom lounging and jetsetting seemed the perfect 1990s fantasy. At the other end of the spectrum, readers of *The Idler* were solely interested in lounging. The magazine served them a seductive mixture of playful fogeyism and literary laddism

magazines like *The Face*, *Arena* and *City Limits*.

These examples of the renewed vitality of British contemporary culture, which embraces a strategy of juxtaposing high and low, art and commerce, fashion and the markets, are founded in many respects (and this is barely known on the Continent) on an unfavourable socio-economic situation within Britain. During the seventeen years of Conservative rule (1979 – 1997), Thatcherism's creative children experienced the rise of ruthless market-driven economics which maintained traditional values but at the same time redefined class boundaries. For example, without warning and a quarter of a century before the current euphoria surrounding the emergence of a global market, Britain abandoned the car and electronics industries to the competition of German, Asian and American enterprises. Until well into the 90s, commercial calculation predominated over

civic responsibility. The huge, investor-led, London Docklands project typified this attitude, with the redevelopment of redundant docks and wharfs into offices and luxury loft apartments creating an island of wealth in the poorer East End of London. In spite of the ubiquitous prominence of architecture and design in the 1980s, which has gone down internationally in the history of culture as the "decade of design", English product designers are more likely to find potential producers in Italy or Japan, Germany or the United States. Ross Lovegrove works for Cassina and Capellini; Ron Arad for Moroso, Zeus, Kartell and Alessi; Jasper Morrison for Magis, Alias, FSB or Vitra. Apart from the specialist magazines, style pages, record covers or books, contemporary graphic design is more often in demand from nationally subsidised museums, theatres, concert halls and institutions such as the BBC. Complex commissions to large studios like Pentagram

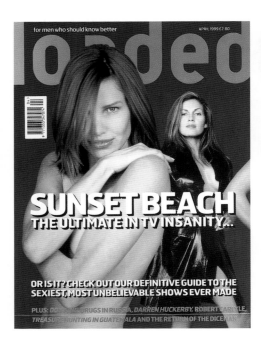

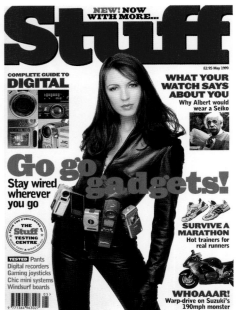

Loaded, aimed at the 'new lad' obsessed with football, cool gadgets and of course naked girls, spawned a revolution in men's magazine publishing by bringing soft pornography off the top shelf. The recently launched *Stuff* is just the latest example, equating girls with gizmos in celebration of the 'designed object'

or IDEO for creating corporate identities and innovative electronic products are more likely to come from abroad.

The economic crisis of 1989 was the final straw and ended the boom for design agencies working for British industry. According to Peter Murray, founder of the British magazines *Blueprint* and *Eye*, today by contrast "the current design community complains of a lack of British clients. Thanks to funds from the National Lottery, our architects are benefitting from a limited number of commissions within the country, but the majority of leading architecture practices earn their living through work from abroad. In contrast to Italy and Spain, the number of potential furniture producers to whom young designers can give work is lower. Smaller, risk-taking firms give the impression rather that the basis for these sorts of commissions is primarily a love of design rather than a sober calculation of costs and estimation of profit". In his informative essay "British Design – At Home and Abroad", (*Highlights – Design from Great Britain*, Museum für Angewandte Kunst, Cologne 1997), Murray continues "The situation at home is responsible for the fact that British architects are designing the German Parliament, British fashion designers are taking over the helm of the French couture houses and the Koreans are

commissioning the British to build their airports, railway stations and office blocks".

It is in the area of exhibitions above all that this British combination of "design and decline" stands in striking contrast to the presence on the Continent of British designs and British curators. The largest exhibition of European products to have taken place in recent years was "Design and Identity" in Denmark's Louisiana Museum in 1996, which, through more than 700 objects, presented current design in ten European countries. One of the curators of the exhibition was the then London-based editor and design critic, Deyan Sudjic, who presented designers, products and ventures throughout Europe from the point of view of their respective national cultures. This selection was accompanied by the overviews of ten countries which were each assembled by individual designers, critics or curators from these countries. Ron Arad was responsible for the British installation, "The Reinvention of Tradition", which showed the new generation of British designers as the innovators of a long lineage of "Britishness".

A part of the contradictory British identity is not least the relationship with the establishment. Nowhere else are pop singers, musicians or architects given titles: there's no question that it's only a matter of time before the Spice Girls will receive these honours, just as the Beatles, Mick Jagger, Elton John or Andrew Lloyd-Webber have. And its clearly not a coincidence that an extremely successful compendium with the self-explanatory title of *British Excellence* has come out recently which assembles those products, inventions and one-offs that have boosted the economic and cultural self-awareness of this trading island. Burberry coats, hand-sewn shoes and made-to-measure suits from Savile Row, exquisite leather upholstery for cars by Connolly or exorbitantly expensive traditional bathroom fittings with eight layers of chromium plating by Czech & Speake of Jermyn Street, Rolls Royce and Rover limousines (although they have since left British ownership), Wedgwood chinaware and country houses. All these are still the ingredients of "Britishness", at least in the way it is understood on the continent, and provide a brief summary of the melting-

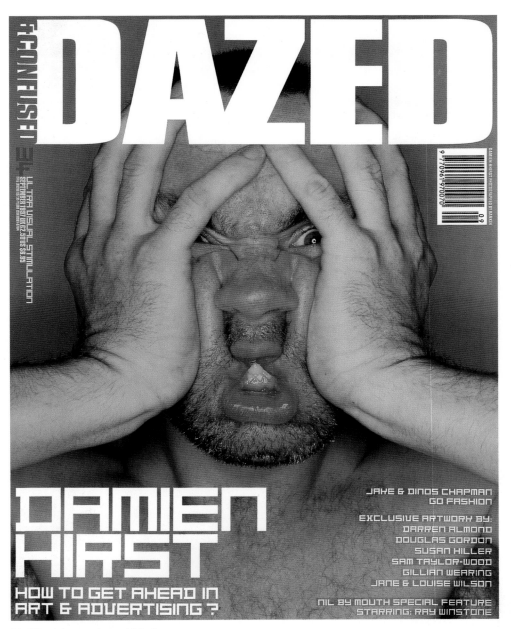

pot reality of the centralist capital city of London which in this respect has more in common with New York or Paris than with Barcelona or Rome. For in contrast to the red double-decker buses are the 12 metre long limousines of the international fat-cat elite; in contrast to the trinity of bowler hat, three piece suit and Financial Times is the sometimes eccentric anti-fashion of Alexander McQueen, Fake London, John Galliano, Vexed Generation or Owen Gaster.

In comparison with students in Germany, Scandinavia or Italy, the numerous graduates of the Royal College of Art and Design or St. Martin's School of Art are sought out very early on by the establishment. Yet, in spite of this network of exposure, the British style manufacturers feel no less disadvantaged in relation to social and commercial possibilities. The fast and well-founded cross-over that makes possible and engenders an advanced media society, is from the point of view of *Lost and Found*, the exhibition that this book accompanies, as much a psychological as an economic reality. We should be wary of judging this recent Britishness as merely hype and consider what happens on the margins as part of the mainstream.

Of all the style magazines published in Britain during the 1990s, *Dazed and Confused* has been the most widely read by the art and design communities. As well as publishing a series of highly controversial – and enormously influential – fashion stories, it has played an important role in bringing artists such as Sarah Lucas and Adam Chodzko to the attention of a wider audience

AntiRom

Jonathan
Barnbrook

Paul
Elliman

North

Nick Bell

The Designers
Republic

Fuel

**Music/club
culture**

**Street
culture**

Art

Michael
Anastassiades

Georg
Baldele

Tord
Boontje

Dunne
and Raby

Shin and
Tomoko Azumi

Mark
Bond

Tom
Dixon

History

Environment

Military

Boudicca

Hussein
Chalayan

Deborah
Milner

John
Galliano

Robert
Cary-Williams

Fake
London

Shelley
Fox

Peter Saville

Tomato

Sunbather

Why Not Associates

Literature

Cross cultural

Collaboration

Konstantin Grcic

IDEO

Ross Lovegrove

Jasper Morrison

El Ultimo Grito

Inflate

Michael Marriott

One Foot Taller

Recycling

Kitsch/ humour

Technology

Owen Gaster

Alexander McQueen

Vivienne Westwood

Vexed Generation

Jessica Ogden

Rick Poynor

Made in Britain
the ambiguous image

As both a profession and a form of practice, graphic design is in a state of flux. While the activities it encompasses can be traced back to the invention of writing itself, the term was not coined until the early 1920s and it is only in the postwar years that it became a commonly accepted form of designation among designers themselves. It has never reached the point of universal public understanding and lexicographers have been notoriously slow to allow it into the dictionary. Now, perhaps, it is already too late. Graphic design is evolving, mutating, merging with other forms of communication. Some of the British designers in *Lost and Found* would still be happy to accept the description, and might even wear it with pride. Others probably don't give it much conscious thought from day to day, and a few would certainly reject it as much too narrow and constricting to describe either the work they make or the way they think.

Any attempt to discover some single unifying characteristic of "British graphic design" would consequently be doomed to failure at this point. It would be quite possible to divide the field as a whole in ways that seemed to indicate the existence of not one but several professions. One of the key themes of British visual communication in the 1990s is its internationalism. Marketing and advertising cross national frontiers. Product branding encircles the globe. The Internet is a growth zone without borders or limits. We see the same films and follow the same celebrities and stars. All of us inhabit this transnational culture and our sense of national identity cannot fail to be modified in the process. Designers, as visual communicators, are acutely aware of developments happening elsewhere – a finely-tuned radar comes with the job – and the more progressive are engaged, through their work, in a continuous process of dialogue with these possibilities.

A certain ambivalence about local identity, an acknowledgement that this too is in a state of turmoil and transition, is one of the results. Designers are helping to question, rethink and revise our national sense of ourselves in the world. "Being English is to know that your so-called greatest achievements are in the past," notes Nick Bell of UNA, which has a partner office in Amsterdam. "[It's] to think that we are better, but to be continually confronted by events that prove we are not; cricket, football, human rights, law and order, justice, European politics, local government, ecology, education, farming, manufacturing." Harsh as this might sound, Bell is quick to cite the flatlands of the Fens, where he grew up, as one of the crucial influences on his own sense of graphic space. In other cases, the ambivalence seems to reveal itself less in what is said, than in what is ignored, rejected, or said instead. The Designers Republic, based in Sheffield, once the thriving home of Britain's steel industry, have built an entire iconography from the graphic flotsam of distant Japanese culture, which they sample, assimilate and reconfigure not as literal tourists (in the early 1990s they had yet to visit Japan) but as tourists of the image. On the other hand, London design team North, engaged to create a new identity for the Royal Automobile Club (RAC), deleted the royal crown and developed a look much closer in feel to the space-age NASA logo than a traditional motoring club. For these British designers, nostalgia is unthinkable.

If "graphic design" now strikes some designers and design-watchers as too rigid a term, this is partly because it sounds like a largely technical procedure, but particularly because it fails to suggest the expanded possibilities of contemporary visual culture. Within graphic design, there has been much discussion of these issues in recent years, and British designers, despite a general reluctance to theorise their work, have played a central role in these changes.

While many clients, even in visually sophisticated sectors such as architecture and fine art, continue to see designers as little more than service-providers whose job is to convey a given message to an audience as efficiently as possible, designers have argued for, and sometimes succeeded in demonstrating, a broader conception of their role. In making this claim, they have received more than a little encouragement from the increasing value that contemporary culture so clearly places on the power of the image in all forms of visual media. At the same time, the now common belief that old categories and rubrics are inadequate;

that disciplinary boundaries can and should, as a matter of principle, be blurred; that culture must accommodate new hybrid forms of expression and will in turn be enriched by them; and – not least – that art itself is rapidly converging with music, fashion, design and club culture in the corporate culture-broker's portfolio have all created fertile ground for designers who seek to take a more exploratory and experimental approach to applied visual communication.

Hence the rise, in Britain and elsewhere, of the idea of the graphic designer as a kind of author. Peter Saville, Tomato, Jonathan Barnbrook, Paul Elliman, The Designers Republic and Fuel create work with a strongly personal component. This is more than just a matter of style, though style is undoubtedly a part of it for some of them. A piece by Tomato, Barnbrook or The Designers Republic is so strongly marked by particular visual concerns and graphic mannerisms that it could be recognised at a glance by anyone familiar with their work. This in itself is something that the generation before them would have resisted. The belief then was that the designer should have no *a priori* style and that the content of the message alone should determine the form. The work of Barnbrook, Tomato and Designers Republic does nevertheless embody a content that goes beyond the issue of form, while remaining tightly bound to it. The fundamental difference from the traditional model is that this is a content supplied by the designers that is extra to the client's basic message. The client buys into the designer's personal vision in the belief that, commercially, this is the right thing for their service or product. If they don't believe this to be the case then they look for a different designer.

With Saville, Fuel and Elliman, personal style plays a much less significant part, although the raw, undecorated "anti-style" gestures of even Fuel's work make it instantly recognisable to aficionados. With Saville and Elliman, the continuities from piece to piece are more apparent in the conceptual method. Saville's music graphics for New Order, inspired by Hollywood film titles and billboard advertising, were unlike anything he had previously created, but the ironic appropriation of existing visual languages and the sense of controlled semiotic play are of a piece with his previous work for the band.

In the same way that a furniture designer such as Tord Boontje improvises salvaged materials into new kinds of form, British graphic designers rework the tired signs, overfamiliar symbols and forgotten manufactured cast-offs of the communications landscape into compelling new combinations. Using bits of plastic, Perspex, wire and die-cast metal found in the street, Paul Elliman fashions a typeface that seems to counter our neurotic wastefulness with an oddly delicate and even poetic image of unwanted matter transfigured and redeemed. Working at the opposite extreme, in the virtual sphere of corporate image-building, The Designers Republic grab, splice and layer company logos, pictograms, spec numbers and slogans into delirious digital collages of pseudo-corporate visual noise, as though the advertising of 50 channels was arriving in one simultaneous brain-scrambling burst on your TV. "This is [our] way," explains DR's Ian Anderson, "of cosmetically re-creating our world, using just those elements with which we feel comfortable, using our environment literally, not filtered through some ism or other . . . it's not always just about the way something looks – although it can be – but it's about context and association. Had the Sony logo represented a garden furniture company, we would not be so interested in it."

While designers such as Why Not Associates and North have established a convincing place for their aesthetic concerns within the commercial sphere, others show signs of uneasiness about the compromises that may be required. Concentrating on a handful of low-key clients, including The Cornflake Shop, a London hi-fi specialist, Paul Elliman has found in design education a protected space in which he can pursue idiosyncratic forms of design research without the need to fit them into restrictive frameworks (he rejects the idea of designers imposing their private agendas on clients). For Elliman, design functions as a form of way-finding, a means of mapping his own coordinates in the world, and his approach has had considerable influence on students. Tomato, by contrast, began pre-emptively

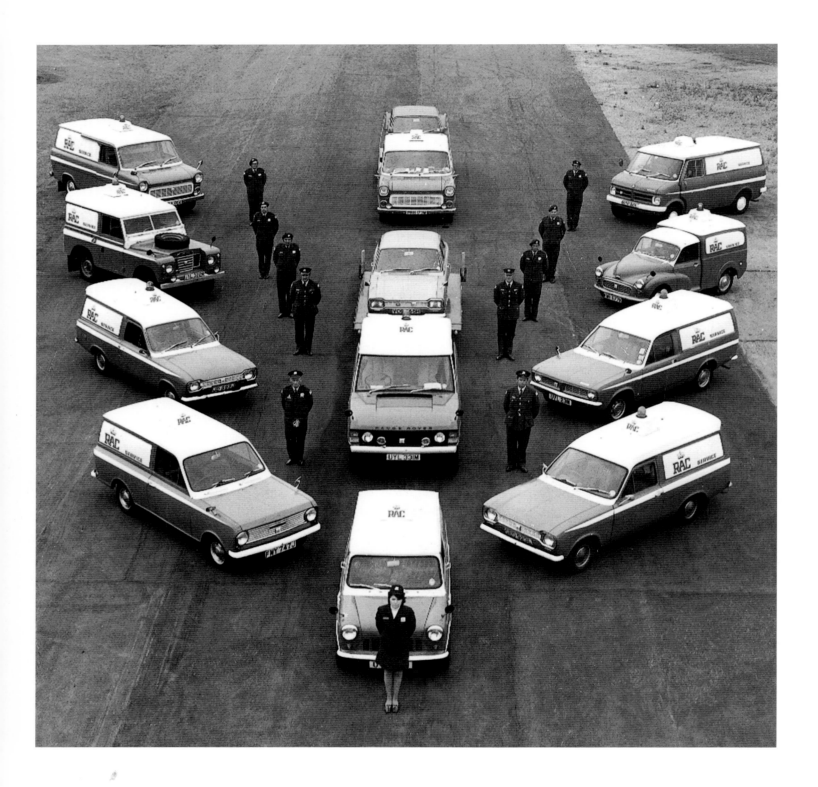

by emphasising their intention to create work for themselves and succeeded in winning this freedom – and no little reward – despite their insistence that the personal "process" of making has priority over their work's final form. "... we have only one work and that is our journey," writes Tomato's John Warwicker, in *Process; a Tomato project*, "we then produce responses to make clear (to ourselves and others) our progress on that journey. Everything that is encountered on that journey becomes subject matter . . . everything constantly shifts and mutates, and no form is exclusive or absolute."

In Jonathan Barnbrook's work the unease is much closer to the surface. His intricate typographic mechanisms, which seem on one level to revel in "designerist" excess, only serve to heighten the irony. Barnbrook, like Tomato, works for advertising and seems deeply uncomfortable with what he finds. In his postmodern typeface designs, produced initially for his own use, and later distributed for sale, he spotlights social and political themes. The latest release, 'Newspeak', printed over a picture of British Prime Minister Tony Blair, is described in Barnbrook's glossy promotional material as a font "for redefining socialism" and "for controlling your image in the media". Another project, 'Apocalypso', is a set of 75 pictograms to be used, his brochure helpfully advises buyers, "in the event of the apocalypse". By shrinking controversial issues and debates to the size of a snappy soundbite – "Corporate Suffocation", "Manufactured in a Repressive Regime", "Technology Makes Killing Clean" are examples – they expose design's disturbing capacity to dissemble and put an acceptable face on almost anything. Even disaster can be spun and branded. If it looks this good, can it really be bad?

A willingness to embrace ambiguity and contradiction is perhaps as close as this group of designers comes to sharing a defining theme. Tomato speak of relinquishing the world of fixed meanings. Barnbrook and The Designers Republic use ambiguity to unsettle and provoke. Paul Elliman believes a graphic message can either clarify or confound, so long as it contains a vital animating spirit. Sunbather's Audiorom extends Tomato's ideas about process, and

revisits composer John Cage's pre-digital theories of indeterminacy, by allowing viewers to enter the process, interact, and generate their own music and poetry. The desire to offer readers, viewers and users open-ended tools with which to create their own meanings is now pervasive within visual communication. It is a measure of this idea's growing cultural impact that industrial designers are beginning to think in the same way. In an essay on "Design Noir", Tony Dunne conjectures that in product design the challenge could soon shift "from concerns of physical interaction (passive button pushing), to the potential psychological experiences inherent in the product. The user becomes a protagonist and the designer becomes the co-author of the experience." This is the approach already taken by Tomato, Anti-Rom, The Designers Republic, Fuel and Sunbather.

As it moves on its inexorable collision course with other media, British graphic design faces some inevitable questions. Designers are creating work that in some respects resembles art, though it certainly isn't taken that way, at this stage, by the art world, and many designers continue, it must also be acknowledged, to argue that self-expression of this kind has nothing to do with responsible design. Most of this work is created for commercial clients, though not always the most interesting examples. Some of it – Barnbrook's typefaces, Fuel's book *Pure Fuel*, Peter Saville's 'Waste paintings', made by recycling his own designs – is self-motivated research and development. Is the personal work in some way invalid or a dead end, even when it finds a viable commercial outlet, because it does not conform to the traditional generic conventions and institutional requirements of either art or design? Is it, in that case, a distraction from what "real" designers should be doing – serving the client with professional neutrality and no discernible point of view?

"As designers, we are communicators," say Fuel. "We are always trying to communicate ideas." Whatever we eventually decide to call it, a form of communication seems to be emerging in Britain, in which some of the most engaging, provocative and challenging ideas and approaches to content are coming from designers themselves.

"... too much like hard work. No. I don't need that."

I'll unplug you now shall I?

Nick Bell studied at the London College of Printing, graduating with a BA in Graphic Design in 1987, and within three years he had been invited back as a teacher. "When I started, it was just after the Berlin Wall had come down," he said in the American typography magazine *Emigre* in 1992. "The first brief I set was the 9'11" brief that was inspired by what was happening at the time in Eastern Europe. I found myself putting a comparable amount of energy into creating problems for someone else to solve as I would put into solving them myself."

Bell discovered that through teaching he could explore and refine his own attitudes towards graphic design, as well as encouraging students to explore more socially responsible approaches to their work. "From looking at most briefs they receive in design schools, it wouldn't occur to designers that graphics could be put to humanitarian or social uses." Bell is now Co-Head of Typo/Graphic studies at LCP.

As a designer Nick Bell built his reputation creating classical music CD-covers for Virgin Classics and the Ultraviolet label. He was a guest designer of *Typographic* magazine in July 1998,

shortly after also becoming art director of the quarterly review of graphic design, *Eye*.

Bell's interest in the ambiguity and complexity of language and imagery as iconic signifier is unusual in its level of intelligence and articulacy. In a 1996 issue of the San Francisco magazine, discussing the nature of nationality, he said: "Being English is to know that your so-called greatest achievements are in the past... to think that we are better, but to be continually confronted by events that prove we are not; cricket, football, human rights, law and order, education, manufacturing... However, those involved really do think we are the best at pop music, street fashion, youth movements, design and now art. Yet... Britain chooses to ignore this visual talent and continues to represent a 'great past' to all foreign visitors – a pre-modern world of Victoriana, neo-gothic decoration, bowler hats and Beefeaters."

Bell's origins in the flat Fenlands of Eastern England have also played an important role in the development of his aesthetic approach, and photographs of such large landscapes appear regularly in

his work, such as the 1998/99 prospectus for the London College of Printing [right]. Bell's spare typography illustrates his refined understanding of semantics. Reducing descriptions of degree courses down to one word, such as MULTIPLIED for the School of Printing Technology, and EDITED for the School of Media, he then activates the word by moving a conceptual cursor across each word [right], to form a meaningful phrase: "This message is MULTIPLIED" for print, and "This message is EDITED" for media.

Multiplied and distributed.

44 SCHOOL OF PRINTING & PUBLISHING

THE SCHOOL OF PRINTING AND PUBLISHING OFFERS A WIDE RANGE OF COURSES TO DEVELOP THE VARIOUS SKILLS INVOLVED IN THESE INDUSTRIES P&P-45

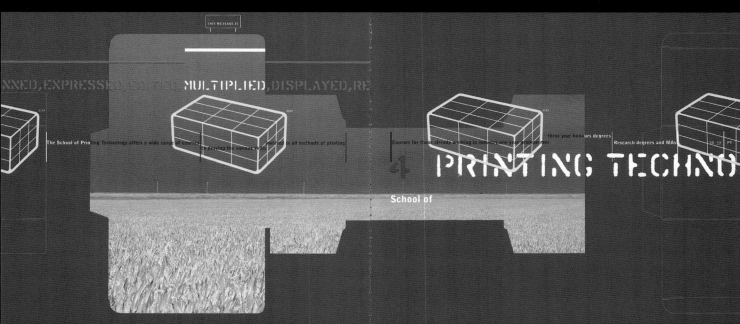

THIS MESSAGE IS

NNED, EXPRESSED, EDITED, MULTIPLIED, DISPLAYED, RE

The School of Printing Technology offers a wide range of courses to develop the various skills involved in all methods of printing. Courses for those already working in industry, one year programmes, three year honours degrees, Research degrees and MAs. 38-39 PT

School of

PRINTING TECHNO

Top left: First Direct
advertising, 1994.
Middle left: spread from
Experience, 1995.
Bottom left, bottom
right and far right:
RAC branding, 1997

first direct
0800 22 2000

24hr person-to-person banking. it's extraordinary.

'EVERYBODY EXPERIENCES FAR MORE
THAN HE UNDERSTANDS. YET IT IS
EXPERIENCE, RATHER THAN
UNDERSTANDING, THAT INFLUENCES
BEHAVIOUR.'

MARSHALL MCLUHAN

MCLUHAN IS RIGHT. EXPERIENCE AFFECTS
BEHAVIOUR. BUT AS OUR PERCEPTIONS
OF THE WORLD AROUND US ARE
CHALLENGED AND EVOLVE WE MUST
CONTINUALLY ASK:

WHAT SHOULD THESE EXPERIENCES BE?

'YOU SEE THINGS; AND YOU SAY 'WHY?'
BUT I DREAM THINGS THAT NEVER WERE;
AND I SAY 'WHY NOT?'

GEORGE BERNARD SHAW

EXPERIENCE EXPLORES THIS QUESTION IN

ITS ORIGIN – THE CROSS-ROADS OF
OPPORTUNITY CREATED BY THE GLOBAL
COLLISION OF MARKETS, MEDIA, CULTURE
AND TECHNOLOGY.

ITS DESTINATION – THE IDEAS OF
THOSE WHO LIVE ON THE EDGE, RELISH
NEW CHALLENGES AND RENOUNCE
CONVENTIONAL THINKING.

ITS PURPOSE – TO INSPIRE YOU AND
IMPRESS UPON YOU A SENSE OF
ADVENTURE, EMPOWERMENT AND
POSSIBILITY.

'WE KNOW WHAT HAPPENS TO PEOPLE
WHO STAY IN THE MIDDLE OF THE ROAD.
THEY GET RUN OVER.'

ANEURIN BEVAN

WE ANTICIPATE VIRTUAL SHOPPING
MALLS AND DIGITAL SUPERHIGHWAYS.

Sean Perkins and Simon Browning met
in 1987 while working together at graphic
design company Peter Leonard Associates.
Browning had graduated in 1984 from
Lancaster University (then called Preston
Polytechnic), while Perkins had recently
finished his MA course at the Royal College
of Art. Perkins was already well-known
thoughout the graphic design community
in Britain for his passionate approach to
his subject, and an extensive collection
of modernist print graphics.

Perkins and Browning joined graphic
design partnership Cartlidge Levene at the
end of the 1980s, where they worked on a
series of high-profile culturally led projects,
including *Issue*, a magazine for London's
Design Museum. Perkins and Browning
joined brand consultants Imagination in
1993, where their work with brands such
as Ford led to their appointment by Midland
Bank in 1994 to launch First Direct [left].
It was a radical departure for British high
street banking, and an award-winning
strategy which successfully integrated the
bank's marketing and brand requirements.

In 1995 Perkins was responsible for
the concept and design of the critically
acclaimed book *Experience*, [left] in
which he curated photographs of art,
people, places and events which he had
collated from an eclectic range of sources.
The art director had become author, and
the project spawned a wave of similar
books in which architects, designers and
artists offered up their own selection of
inspirational images to a public with
an apparently insatiable appetite.

Having formed their own company
North in 1995, Browning and Perkins
continued to pursue a resolutely modern
approach, and their single-mindedness
was rewarded in 1997 when they won the
contract for a complete redesign of the
corporate identity for the RAC (Royal
Automobile Club), one of Britain's great
establishment institutions. The result
was more radical than most of the RAC's
membership could have imagined: the
royal crest was abandoned, and replaced
by new lettering [right] reminiscent of the
NASA logo of the 1970s. The polite white
colouring of the organisation's vehicle fleet
was replaced by an unmistakeable orange
highlighted by red and white stripes,
and the respectable but dull uniform of
RAC employees was superseded by orange
waterproof jackets produced by the
manufacturer of high tech clothing
for climbers, North Face.

Despite the predictable chorus
of complaint from a small number
of members, within two years the
RAC identity has been established as
a memorable part of Britain's urban
landscape. North, meanwhile, continues
to search for corporate clients with
outmoded identities which are ripe for
Perkins and Browning's unique brand
of modernisation.

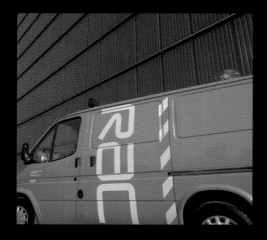

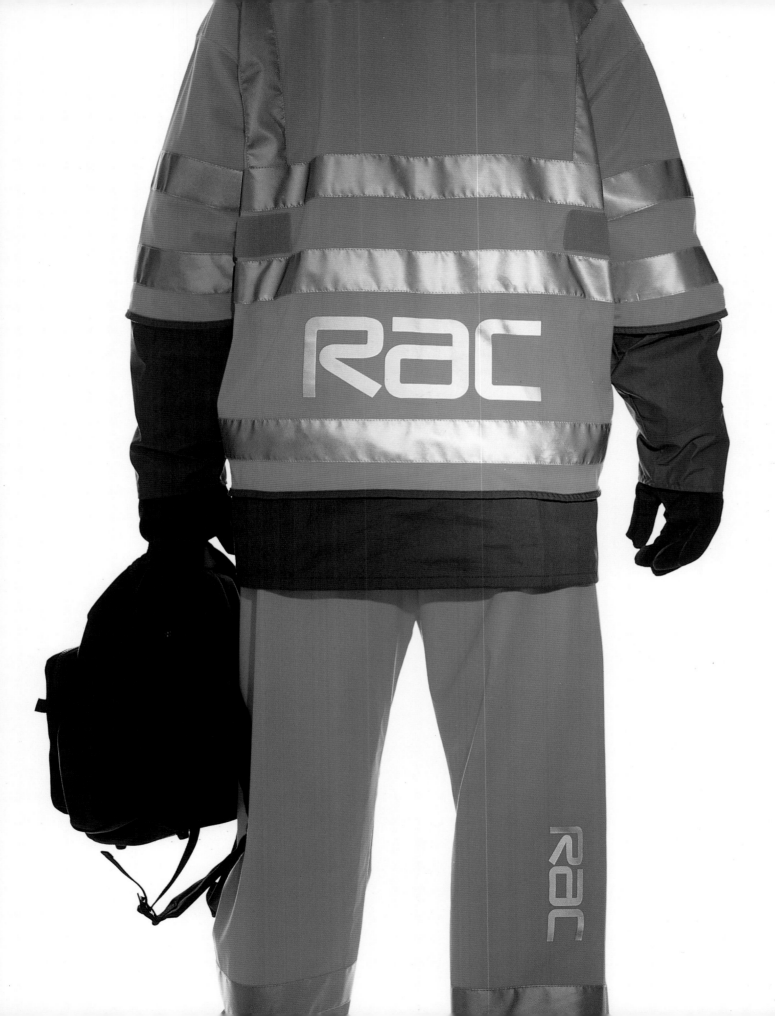

Below: Two album covers
for New Order, 1993.
Top right: album sleeve
for Pulp, 1998. Below
right: *Visionaire* magazine,
designed in association
with Alexander McQueen;
photograph by Nick Knight

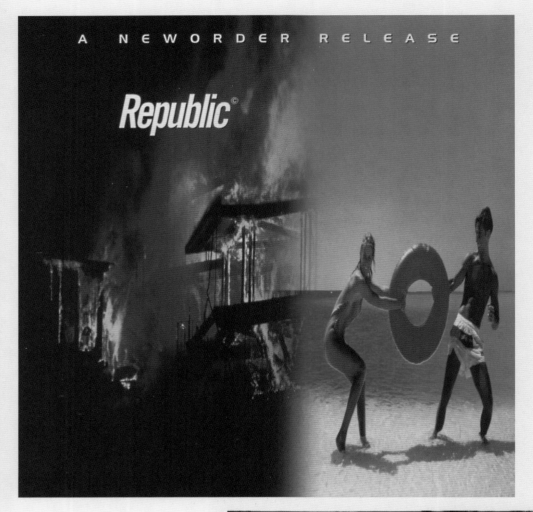

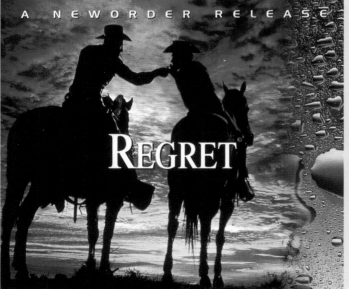

Having studied graphic design at Manchester Polytechnic, Peter Saville became a founder partner of Factory Records in 1979. There he was responsible for some of the most memorable record sleeve designs of the post-punk era, such as 'Unknown pleasures' for Joy Division. By 1983 he had founded Peter Saville Associates, with music industry clients including Roxy Music, Ultravox, Peter Gabriel and New Order, art institutions such as the Whitechapel Art Gallery and the Pompidou Centre in Paris, and fashion clients such as Yohji Yamamoto and Jil Sander.

In 1990 Saville began the first of two unsuccessful forays into the mainstream, wanting to ply his maverick talents at more conventional design consultancies, first Pentagram in London and then Frankfurt Balkind in Los Angeles. He returned to London in 1994, and is now a freelance consultant to music and fashion clients.

Peter Saville's approach has more in common with fashion and music than graphic design as traditionally represented: his work emphasises quotation and appropriation. "I had – and to some extent still have – more a fashion designer's or stylist's sensibility than a graphic designer's," he told *Eye* magazine in 1995, "Fashion's existence is dependent on reference and reinterpretation, season after season." Throughout the 1980s, Saville drew on postmodernist and neo-classicist movements in architecture and contemporary art, and in particular the art scene in New York. His cover for Joy Division's album 'Closer' featured a 1980 Schnabel painting, 'Ornamental despair'.

At a conference in the Netherlands in 1996, Saville stated that his major contribution to the graphic design debate had been made during the 1980s. He went on to express his admiration for the contemporary art scene in London and the honesty of its practitioners. This sense of being outside the mainstream, coupled with a sensibility for art practice, appears to have liberated Saville to experiment with more tangential strategies which have yielded some powerful results. The design process for his 'Republic' record sleeve for New Order arises from word associations Saville arrived at while listening to the music. The words were used as the starting point for searches through photo libraries, which yielded images related to the original material in a complex and distant way.

Philosophy graduate, ex-bass player, and ex-DJ Ian Anderson formed The Designers Republic in the South Yorkshire city of Sheffield in the early 1980s. "I came to Sheffield in 1980 because of Cabaret Voltaire and The Human League," said Anderson in an interview with *Blueprint* magazine in 1996. He launched a fanzine *Voodoo Voodoo* in 1982 and then began designing flyers and record sleeves for friends. Soon afterwards he made use of a government Enterprise Allowance Scheme to launch The Designers Republic in 1985.

Anderson used his network of Sheffield musicians to create a client base which, like the musicians, gradually spread to London, and then abroad. The network of contacts made up for Anderson's lack of expertise: "After we'd had our first computer for six months, we'd only worked out how to muck around in Hypercard. Then we discovered Freehand. Freehand is God. Computers are good," he told *Blueprint*'s correspondent, in a tone (like so many of his designs) leaving open the possibility that he didn't mean it.

The Designers Republic's approach has clearly tapped a rich vein and their client list reads like a roll call of the commercial standard-bearers of youth culture of the 1990s, with MTV, Adidas (USA), Sony Interactive Entertainment, and Swatch as well as a group of cutting-edge advertising agencies on the list of those not involved in the music business. Clients associated with the music industry include Warp Records, Autechre, Ministry of Sound, Pulp, JVC, Warner Bros Records and a series of bands and smaller independent record labels.

Despite the enthusiastic response from their clients, some of DR's most memorable work has emerged from personal experiments, often involving the deliberate infringement of other people's copyright, or the cheeky appropriation of commercial images in a manner reminiscent of the sampling which is so common in contemporary dance music. A 1994 issue of the American typographic magazine *Emigre* was devoted entirely to The Designers Republic, and featured one of the group's fictional icons, Miss Sissy, surrounded by Japanese lettering and fake company logos. It became the magazine's best-ever selling issue.

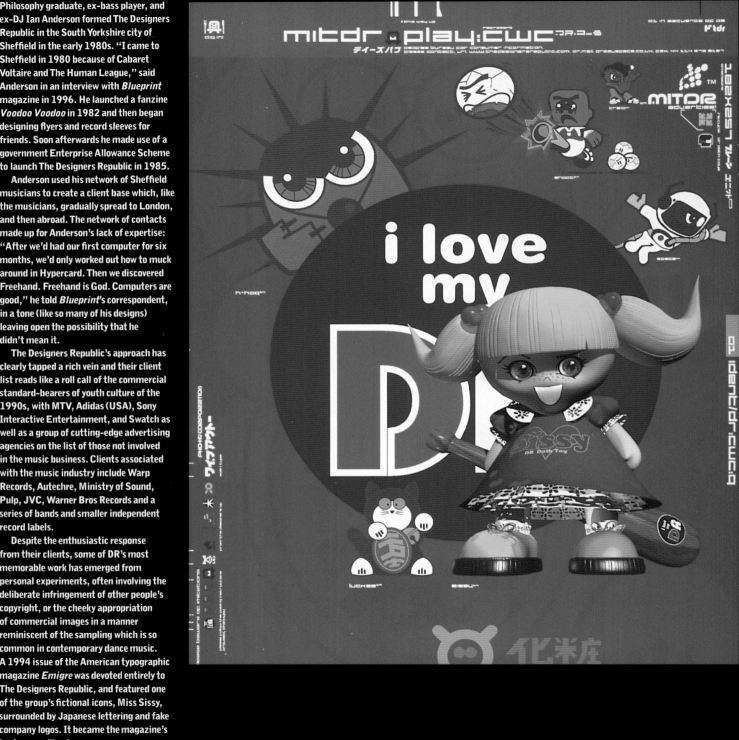

LET'S
HEAR IT
FOR
CONSUMER
FASCISM

NUMBER OF COMMERCIALS SEEN BY AMERICANS BY AGE EIGHTEEN 350,000

eft: 'Miss Sissy',
ork for Japanese magazine
lustration, entitled
Play', 1997. Above: work
r *Illustration*, 1997.
ight: album sleeves for
ance band Autechre, 1995

Autechre. tri

a fax magazine, 1991.
Below right: promotional
work for London hi-fi store
The Cornflake Shop, 1992.
Right: objects found by the
roadside collated for 'Bits'
typeface, 1995

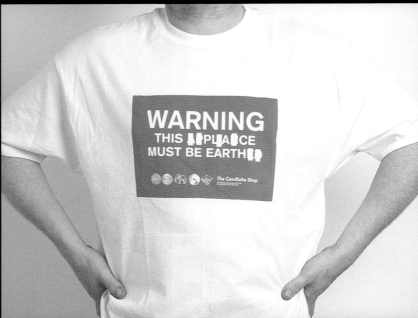

Paul Elliman was the subject of intense media interest early in his career: following a successful stint as art director of the jazz journal *Wire* between 1986 and 1988, he won a D&AD Gold award in 1991 for *Box Space* [left], a fax magazine which consisted of vast lengths of scrolled fax paper which had to be assembled by the recipient. Partly as a result of this early risk of over-exposure Elliman, like industrial designers Tony Dunne and Fiona Raby, opted to limit his commercial work to a small number of clients, preferring to investigate his design ideas through teaching. He is currently a visiting assistant professor at Yale University.

It was through a teaching project with students in 1995 that Elliman began his work on 'Bits', a typeface constructed from roadside detritus [right]. Elliman collected pieces of spent metal and plastic which he saw beside the road and scanned them into a computer to create letter forms. Elliman contributed the resulting font to the typography magazine *Fuse*, delivered to its readers on floppy disk. Its creation is typical of Elliman's method, which often deploys a strategy or pre-determined program of events to dictate the outcome, subordinating formal or aesthetic concerns so that the outcome is a record of the strategy. By deciding

input consisting of editing, rather than creating images.

One of Elliman's long-standing commercial clients is the London-based hi-fi store, The Cornflake Shop, with whom he has collaborated on a regular basis since 1987. A promotional t-shirt for the shop bearing the slogan "Warning, this place must be earth" [above] represents a sophisticated and gently subversive appropriation of the standard warning on British appliances, which reads "Warning, this appliance must be earthed." As well as drawing wittily on the language of hi-fi as the starting point for the design, Elliman also drives home a simple message: that looking hard, and reading text carefully can yield striking results.

In conversation, Elliman mentions a variety of literary references, including writers such as Italo Calvino, Walter Benjamin and Georges Perec. In addition, his use of ironic juxtaposition and procedures derived from chance suggests elliptical references to work by artists such as Richard Wentworth and early pieces by Tony Cragg, as well as the experimental composer John Cage.

Paul Elliman

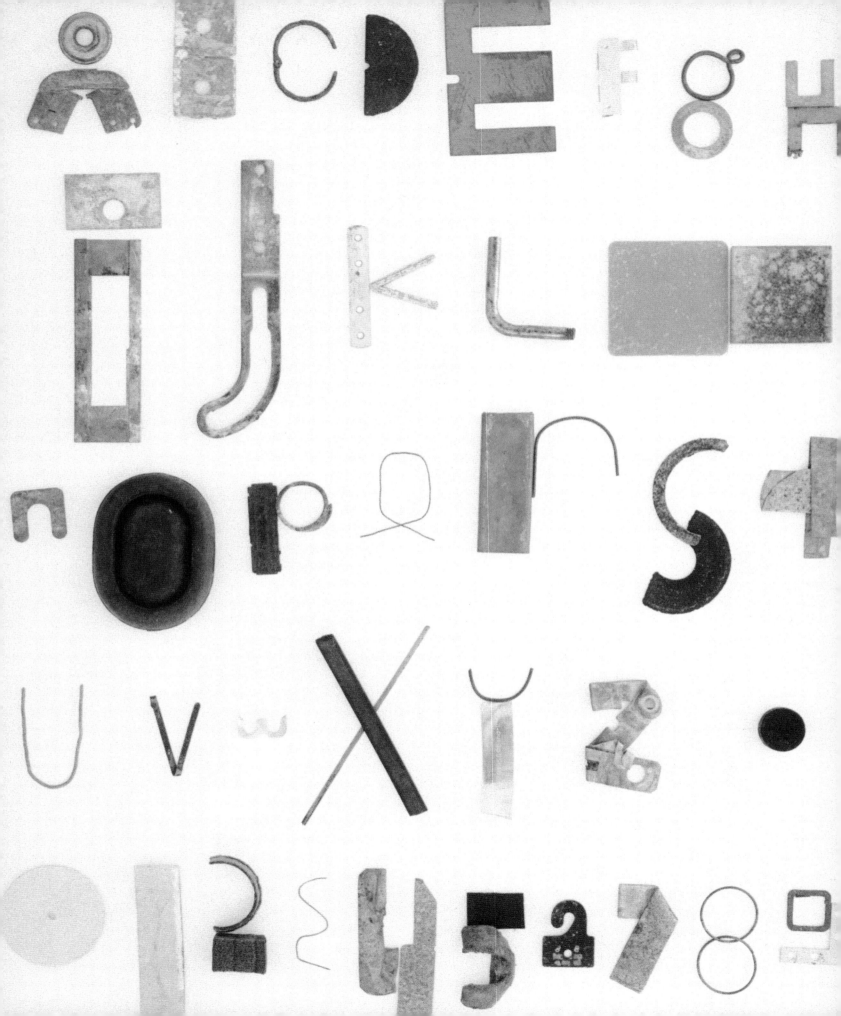

Above left: spread from
*mmm.... skyscraper I love
you*, a collaborative project
with Underworld, 1994.
Below left and above right:
spreads from *Process:
a Tomato Project*, 1996.
Below right: pages from
Black Scrapbook by William
S. Burroughs and Brion
Gysin, c. 1963-64

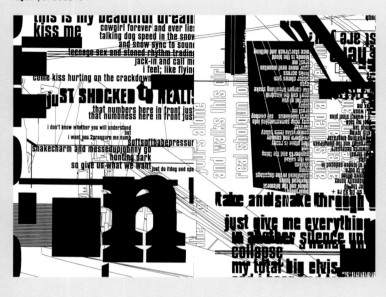

Tomato has been in existence since 1991. The eight-strong team of writers, photographers and graphic designers currently includes Steve Baker, Dirk van Dooren, Michael Horsham, Karl Hyde, Rick Smith, Simon Taylor, John Warwicker and Graham Wood. Each member works individually or as a team in response to the requirements of Tomato's projects.

"The creative process is itself a fragile thing," says John Warwicker in Tomato's book *Process* (Thames & Hudson, 1996). "One moves in a direction hoping to find something, both recognisable and at the same time unrecognisable, something comforting but exciting." The book's celebration of the process of design rather than its result represents Tomato's most marked contribution to British graphics in the 1990s. In contrast to the strategies of the 1980s which emphasised pre-programmed visual results, Tomato demonstrate that the tangible mark of the designer is relevant, even desirable. "This weaving within and without oneself can be ultimately rewarding if one is brave enough

to follow this path," they argue. Tomato's approach has been highly influential in legitimising the authorial role of the graphic designer.

Perhaps not surprisingly, given the group's location in the hallucinogenic buzz of Soho, Tomato's work often appropriates and layers images and words from sources as diverse as literature, philosophy and advertising. *Process*, for example, juxtaposes a filmic approach to images with quotes from Ludwig Wittgenstein, Al Alvarez, Aristotle and John Cage as well as many others. Photographs in the book are treated so as to demonstrate that each alone is unimportant, whereas taken in sequence they build to form a blurred, but memorable impression.

Two of the group's members (Hyde and Smith) are also part of the dance group Underworld, with whom Tomato has collaborated on a number of projects, including live graphic backdrops to accompany Underworld's performances. One collaboration, the book *mmm... skyscraper I love you* (Booth-Clibborn Editions, 1994) is said by the band to have formed part of

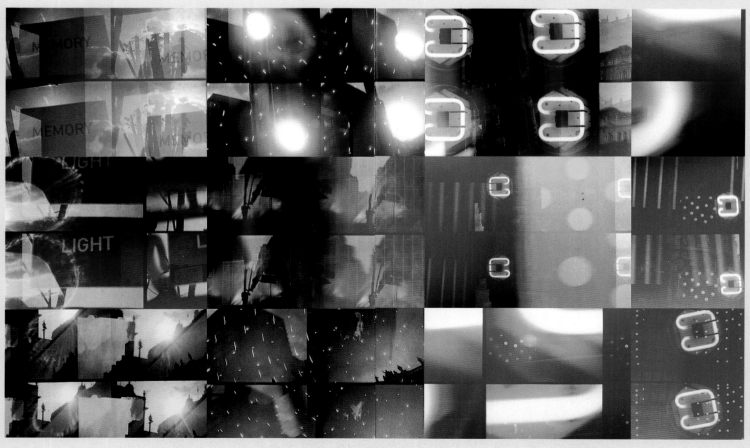

the development process for their album 'dubnobasswithmyheadman'. An ironic and self-indulgent exercise in typographic appropriation, it is described as a map of a journey through the streets of New York. Printed in black and white on low grade paper, layers of found and overheard words recorded in heavy black type build into dense and often completely abstract compositions. It is difficult to read and certainly impossible to approach in a conventional manner.

Building on its sensibility for filmic imagery, Tomato has recently turned its attention to film and video direction, once again blurring the boundaries between disciplines. A video for Underworld's 1999 single 'push upstairs' is at first calm, naturalistic and rather bleak, then slowly begins to melt at the edges, a process which, like a virus, eventually envelops the entire screen, leaving the viewer with a sense of a world being invaded, and transformed into something unknown.

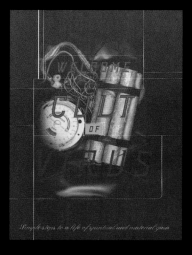

This page: pages and cover from Barnbrook's catalogue for the Virus Foundry, 1997. Right: wallpaper designed in collaboration with Damien Hirst for Pharmacy restaurant, 1997

Typographer Jonathan Barnbrook studied graphic design at Central Saint Martins and then the Royal College of Art between 1988 and 1990. Since 1993, as a titles director at Tony Kaye films, he has worked on TV campaigns for a large number of commercial clients including Volvo, Mazda, VW, Vidal Sassoon and Lloyds Bank. However, behind this commercial success, an obsession with typography and the subliminal associations of letter forms has always been at the heart of his work.

The names of his fonts – such as 'Exocet', 'Prozac' and 'Manson' – are just as important to him as the way they look. 'Manson', named after the American serial killer Charles Manson, even generated comment in *Time* magazine and was renamed 'Mason' by its US distributors as a result of the controversy (rendering it impotent in Barnbrook's view).

In 1996 Barnbrook launched his own font foundry, provocatively called Virus, revelling in the idea that purchasers of his typefaces would be forced to insert a floppy disk entitled Virus into their computers.

From his earliest work Barnbrook has used design as a platform for personal commentary, often of a political nature. "I'm interested in playing with the idea of authority and making it work against itself, to destroy it," he said in *Eye* magazine. The catalogue for the Virus Foundry [left] includes polemical statements which are reminiscent of statements by the American poet William Burroughs: "…Virus is not responsible for its own actions. Virus is the language you use to speak to others. Virus is in league with the CIA. Virus is the end of the millennium…'

In an interview with Rick Poynor in the American design magazine *I.D.* in 1997, Barnbrook said: "I try to see my work in its broader social context, but I do it for myself as well. I want to get intellectual satisfaction out of it, but I want it to function." No project could illustrate this attitude better than Barnbrook's close collaboration with the artist Damien Hirst. Their book project *I want to spend the rest of my life everywhere with everyone one to one always forever now* [overleaf] shatters the mould of the traditional art monograph, the typographer activating the artist's words which float and skim across expanses of austere black. Using tactics such as die cuts, pull tabs and a host of ▶

200 mg

drous)

TICALS P. 789

aspirin)

TICALS P. 789

.A.
naleate,
e HCl)
ng

TICALS P. 789

. Half
e HCl,
naleate)
g

TICALS P. 789

cetaminophen)
ng

TICALS P. 790

D®
guaifenesin)
mg

TICALS P. 790

Ic®

C44* 10 mg C46* 15 mg

†Compazine® Spansule®
(prochlorperazine)

RX SMITHKLINE BEECHAM PHARM. P. 2244

C66* 5 mg
Also C67* 10 mg, C69* 25 mg

†Compazine®
(prochlorperazine)

RX SMITHKLINE BEECHAM PHARM. P. 2244

2 mL (5 mg/mL)

†Compazine® Vials
(prochlorperazine)

RX SMITHKLINE BEECHAM PHARM. P. 2247

D14* D16* D17*
5 mcg 25 mcg 50 mcg
liothyronine as the sodium salt

Cytomel®
(liothyronine sodium)

C-II SMITHKLINE BEECHAM PHARM. P. 2248

E14* 15 mg
Also E12* 5 mg, E13* 10 mg

†Dexedrine® Spansule®
(dextroamphetamine sulfate)

C-II SMITHKLINE BEECHAM PHARM. P. 2248

E19* 5 mg

†Dexedrine®
(dextroamphetamine sulfate)

RX SMITHKLINE BEECHAM PHARM. P. 2250

E33* 10 mg

Dibenzyline®
(phenoxybenzamine HCl)

RX SMITHKLINE BEECHAM PHARM. P. 2250

Dyazide®
(hydrochlorothiazide, triamterene)
25 mg / 50 mg

RX SMITHKLINE BEECHAM PHARM. P. 2238

30-unit vial

Eminase®
(anistreplase)

RX SMITHKLINE BEECHAM BIO. P. 2255

10 mcg / 0.5 mL 20 mcg / mL
Pediatric Unit-Dose Adult Unit-Dose
Vials Vials

Engerix-B®
(Hepatitis B Vaccine [Recombinant])

RX SMITHKLINE BEECHAM PHARM. P. 2257

300 mg

Eskalith®
(lithium carbonate)

RX SMITHKLINE BEECHAM PHARM. P. 2257

J10* 450 mg

Eskalith CR®
(lithium carbonate)
Controlled Release Tablets

C-IV SMITHKLINE BEECHAM PHARM. P. 2258

30 mg

Fastin®
(phentermine HCl)

RX SMITHKLINE BEECHAM PHARM. P. 2259

0.3 mg 0.625 mg

1.25 mg

2.5 mg

Menest™
(esterified estrogens tablets, USP)

RX SMITHKLINE BEECHAM PHARM. P. 2262

Ornade® Spansule®

RX SMITHKLINE BEECHAM PHARM. P. 2265

PARNATE* 10 mg

Parnate®
(tranylcypromine sulfate)

RX SMITHKLINE BEECHAM PHARM. P. 2267

20 mg

30 mg

Paxil™
(paroxetine HCl)

RX SMITHKLINE BEECHAM PHARM. P. 2273

Single-Dose Vials

Rabies Vaccine Adsorbed

RX SMITHKLINE BEECHAM PHARM. P. 2275

500 mg

750 mg

Relafen®
(nabumetone)

RX SMITHKLINE BEECHAM PHARM. P. 2277

RIDAURA* 3 mg

Ridaura®
(auranofin)

RX SMITHKLINE BEECHAM PHARM. P. 2279

10 mg
Concer

10 mL (2
Multi-dos

†Stela
(trifluopera

RX SMITHKLINE BEE

Single-dose unit

Tagan
(cimetidir
Liqu

RX SMITHKLINE BEE

200 m

300 r

Tagam
(cimetī

RX SMITHKLINE BEEC

▶ complex paper engineering effects (executed in collaboration with designer Herman Lelie), and often parodying the visual conventions of medical and science textbooks to illustrate Damien Hirst's ideas, the book adds up to a landmark in art publishing. "We were trying to make an art book entertaining and a bit more populist," says Barnbrook. Requiring over a year to complete (and rewarded with a Best of Category prize in the *I.D.* Annual Design Awards in 1998), the project exhausted Barnbrook; but the collaboration with the artist did not end there. For Hirst's high-profile restaurant Pharmacy in London's fashionable Notting Hill, Barnbrook designed wallpaper decorated with a variety of prescription pills taken from a pharmaceutical catalogue.

[previous page]

"there is a dream that is apparently widespread among forensic pathologists—the death dissectors, the gore explorers, the rummagers in the tossed away envelope of the soul, up to their elbows in it. the autopter is performing an autopsy on a member of his family. he has taken out the organs, can't get them back in again, but must go on sewing up the body—which is alive, though dead—by day. the harder he labours with the viscera, the more panicked he becomes, the more insistently they slop out

again… hearing about the dream i of course immediately thought of damien, who at this point is up to his neck in it.

'let's go in'. it's interesting that surgeons and safe-blowers, in their popular portrayals at least, use the same expression to inaugurate their precise, premeditated, violently invasive procedures: the alarm hardware decommissioned and mute; the human wetware morphised and sundered (inverted, divided)."

gordon burn, 1993

book *I want to spend the rest of my life everywhere, with everyone, one to one, always, forever, now* designed in collaboration with Damien Hirst, 1997

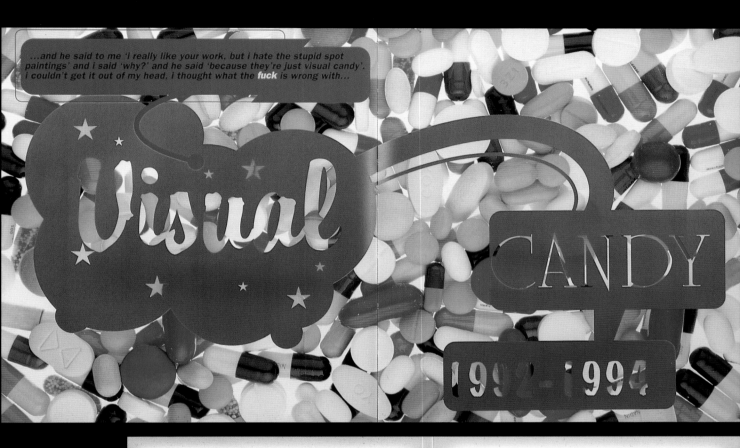

...and he said to me 'i really like your work, but i hate the stupid spot paintings' and i said 'why?' and he said 'because they're just visual candy'. i couldn't get it out of my head, i thought what the **fuck** is wrong with...

Visual CANDY 1992 - 1994

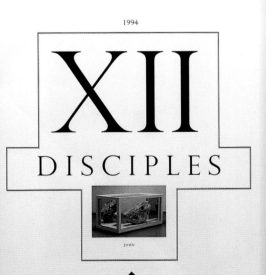

1994

XII DISCIPLES

JOHN

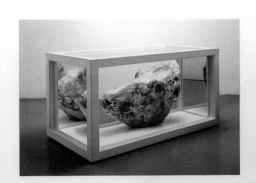

MATTHEW

by Andy Allenson, a design graduate of Goldsmiths; Nick Roope, who had studied sculpture at Liverpool University; and Luke Pendrell, a fine art graduate from Leeds University. Anti-Rom was launched officially in February 1995. It has since grown to a total of 13 people, moving into the Soho-based offices of Tomato in early 1997.

Anti-Rom's work takes on many forms including print, performance, internet, CD Rom, installation and film. Projects for commercial clients include a series of projects with Levi Strauss, a website for the band Massive Attack in association with the London advertising agency St Lukes, and CD Roms for the BBC and shoe company Caterpillar. All their work, whether commercial or personal, fuses experimentation and technical innovation The company's own website [extracted pages, left] experiments with forms of language made possible by non-linear and interactive media. A series of vignettes and iconographic sequences serves to encourage web-literacy (mouse manipulation, use of the cursor to trap moving objects and so on) with a lightness of touch not achieved by other, more didactic teaching tools. It is an approach which demonstrates a powerful affinity with electronic music and computer games.

A project with London's Science Museum completed in 1997 employs interactive installations using touch-sensitive technology to communicate scientific ideas to children. "We've used a Richard Scarry line-drawn aesthetic overlaid on the direct scanning of materials such as wool," says Rob Lequesne. Meanwhile, other members of the group are actively pursuing ways in which to fund their investigations into interactive sound and the development of interactive music engines. As well as researching on-screen generative music, Anti-Rom has experimented with active live performance, using touch sensors on stage to create music in response to dance movements. It is a shift in emphasis from form to method which epitomises the group's work.
http://www.antirom.com

In the summer of 1992 Rob Lequesne, Sophie Pendrell, Joe Stephenson, Andy Polaine, Andy Cameron and Tom Roopeq graduated from the University of Westminster with a BA in Photography, Film and Video. The group was impressed by Dutch multimedia magazine *Mediamatic*, and in particular by a CD Rom distributed with it. 'Blind Rom', developed by artist Gerard van der Kaap, was a powerful attempt, at a relatively early stage in the life of the medium,

to question ideas about the role of the CD.

The graduates wanted to emulate van der Kaap's experimental efforts, and with the help of a £5,000 grant from the Arts Council they made their own CD Rom, entitled 'Anti-Rom'. "At the time, we had no particular ambitions to do business," says Rob Lequesne, "but the CD was so successful that we went back to the Arts Council for quite a lot more money and the whole thing snowballed."

The Westminster graduates were joined

Top left: Audiorom. Top right: multimedia 'mixing desk' for Oil. Below: sheet music from 'Water Music' by John Cage, 1960; Edition Peters No. 6770 © 1960 by Henmar Press Inc., New York, reproduced by permission of Peters Edition Limited, London

There are two sides to Sunbather: the highly commercial and the joyously experimental. It is a blend which epitomises the approach taken by many creative designers in Britain, and resulted in Sunbather's production of some of the most intriguing experiments in multimedia graphics undertaken in Britain to date.

Six years ago, the terrain of web design was largely uncharted in Britain. Mike Bennett and Will Julian, who met at the London College of Printing and graduated in Graphic Design in 1993, went their separate ways, with Bennett art directing music magazines such as *Generator* and *24/7*. Julian was more interested in a fine arts-based approach to graphics. By 1994, Bennett had become art director at the young company WebMedia. There, he

designed a web site for the launch of an album by musician Annie Lennox. "It was the first commercial website in the UK." he says.

The following year Bennett and Julian reunited to launch Sunbather. Their aim was to experiment with creative possibilities of multimedia, but the company was soon overwhelmed by the massive demand for commercial websites and with the successful creation of a site for the Children's Channel and another for Radio 1, the company began a period of rapid expansion.

In 1996, alongside the commercial projects, Sunbather began developing an experimental CD project entitled Audiorom [top left]. The application offers an interactive approach to music making, based on typographic or screen-based

choices made by the user, which are then fed into a sound-production system to create music. It is an approach reminiscent of the techniques of composer John Cage, whose musical scores [below] often relied on elements of chance. "Out of the Audiorom CD, which was basically a game, we had the idea of an application based on the same principles, and that is how our record label Oil was conceived," says Bennett.

"Oil [top right] is a multimedia record label which focuses as much on multimedia as it does on music," says Bennett, "and it draws on the fact that this country is now full of back bedroom DJs who are downloading music onto their consoles and doing their own remixes." However, unlike other multimedia applications, which in Bennett's view give the impression that they are designed for software engineers, Oil uses the visual language of outmoded computer games such as Battle Tanks and Pac-Man to help users navigate the music-making system.

Sunbather's creative success led to its acquisition by the American multimedia company Razorfish in 1998, where Bennett is now creative director. "It's nice not to have to worry about paying salaries any more," he says, but the vestigial spirit of the entrepreneur clearly remains. "Something inside me says, how on earth did I find myself working for a corporate giant like this?"

Pure
product
is
a
product
with
no
application.

This page: pages from
the book *Pure Fuel*,
1997; opposite: poster
for Fuse typeface

HYPOALLERGENIC: sensitive skin

Original

Copy

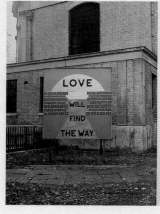

LOVE
WILL
FIND
THE WAY

Trust,
Donate.
Do All
That Is
Asked.

PORNO-GRAPHY NEEDS ↓YOU↓

FIRST
WIG 1675

Peter Miles, Damon Murray and Stephen Sorrell formed Fuel while studying at the Royal College of Art in 1990. They set up their practice in Spitalfields in East London and became associated with the Market Café, also a regular haunt of the artists Gilbert and George.

Reacting against the technology-led gymnastics of much contemporary design, Fuel's work utilises simple artless typography, found type and reportage photographs. "Decoration can be confusing," says Sorrell. "There's no need to flower things up. We are interested in the undesigned look." Taking their inspiration from everyday images and the seemingly mundane, Fuel's communications are an ironic, often cynical, sometimes ambiguous reaction to what they perceive to be a surfeit of information around them.

Often Fuel's most provocative work has been self-authored. While still at the Royal

College of Art, the group launched a magazine, *Fuel*, in which they explored and questioned attitudes (including their own) to a series of subjects. Issue 1 was titled 'Girl', issue 2 'Hype', and issue 4 'Cash'. Each of the magazine's six issues carried a different four-letter title: the final issue was simply 'Dead'.

Fuel's incisive editorial approach to visual communication led to a commission to write, edit and design the book *Pure Fuel* by Booth-Clibborn Editions in 1996 [excerpts, previous page]. Its tone and content deliver a message which cannot be explained simply by looking at the images or reading the words in isolation. *Pure Fuel* is a powerful example – confident and unapologetically British in style – of 'visual communication', a term being used increasingly regularly to describe overtly-authored projects by practitioners whose output goes well beyond classic boundaries of graphic design.

Below left: spread from
Time magazine, 1998.
Below right: self-promotional
flyer advertising Why Not's
tenth anniversary. Right:
cover for *U&lc* magazine,
1997. Overleaf: 'synapse',
installation for Kobe Fashion
Museum, Japan, 1997

Scientists are using advanced computer technologies to increase, enhance and extend the power of the senses

In the Realm of the Senses

Andy Altmann and David Ellis formed Why Not Associates after leaving the Royal College of Art in 1985, initially in partnership with Howard Greenhalgh, who soon broke away to specialise in commercials and pop video directing under the banner of Why Not Films. The studio became well-known for its creative approach and it was an atmosphere which harboured young talent: both Jonathan Barnbrook and Graham Wood, a founder member of Tomato, began their careers with Why Not.

Why Not Associates' wide-ranging output includes a set of postage stamps commemorating the fortieth anniversary of the Queen's Coronation, programme titles for the BBC, the graphic design for 'The Power of Erotic Design' exhibition at London's Design Museum in 1997 and a book to coincide with the Powerhouse::UK exhibition in 1998. Their very English combination of heritage and rebellion was described by the British social commentator Peter York as "punk and pageantry" – but their work, although firmly rooted in British traditions and culture, developed its particular style as a result of being filtered through the group's strong affinity with European, and especially Dutch visual culture.

The layering and filtering of cultural and visual references in Why Not's designs have not always been readily understood by clients or journalists, who have tended to focus only on the seductive surface of the group's typographic experiments. In fact,

Why Not interact closely with the texts with which they are working, combining multi-layered text zones and image-fields in their own brand of 'visual editorialising'.

In an audio-visual installation, 'Synapse' [overleaf], commissioned for the Kobe Fashion Museum in Japan in 1994 and completed after the earthquake in 1997, 1500 slides are projected from 24 hidden sources onto all four walls as well as the pillars and floor in the museum's central square gallery. Attempting to answer the question 'What is fashion?', their answer ('fashion is change') is a densely-layered evocation of the context which generates change, and was described in *Blueprint* magazine in May 1996 as 'overpowering', and 'life-affirming therapy'.

The same visual seduction is at work in the flashing neon signs of the Soho strip joints which surround Why Not Associates' studio and they provided an inspiration for their own neon sign, 'Art + type' [right], reproduced on the cover of US typography magazine *U&lc*.

Type the medium and the message

UPPER and lower case

Volume 23, Number 1, Summer 1996

For a free issue of U&lc, please write to U&lc,
866 2nd Ave, New York, NY 10017, USA
or fax to U&lc at 212 752 4752.

The International Journal of Graphic Design and Digital Media

Published by International Typeface Corporation

source

mother nature

shelter

culture

communication

language is not sim
ply a reporting devi
ce for experience bu
t a defining framew
ork for it

BENJAMIM WHORF

talk, shout, whisper
mail, gesture, bark,
phone, fax, e-mail,
send

materials

paper

water

technology

(te nology)

nology

evolve

mother nature

form

shape · form

shelter

ex

difference

perfection

future

communication

great literature is si
mply language char
ged with meaning to
the utmost possible
degree

language is
the dress of
thought

SAMUEL JOHNSON

exchange

materials

stone plastic

technology

harness

invent

Marcus Field

From Luddites to love
a brief history of design

Signs of the times

Thomas Carlyle, the great Victorian essayist and social historian, would be astounded by the exhibits in *Lost and Found*. Not because they are so modern, but precisely the opposite. As far back as 1829 he declared in his work *Signs of the Times* that "there is no end to machinery". As he surveyed the world of post-Luddite Britain it seemed as if nothing could stand in the way of industrial progress. "For all earthly, and for some unearthly purposes," he wrote, "we have machines and mechanic furtherences; for mincing our cabbage; for casting us into magnetic sleep. We remove mountains and make seas our smooth highway; nothing can resist us."

For a long time it seemed as if he was right. The dominant belief in the nineteenth century and for most of the twentieth has been that only through industry will the problems of society be solved. To win wars, to travel on land or sea, in the air, to outer space, to make shelter, furniture and household objects, to clothe and feed ourselves, to give us leisure time, the thinking went, machines must be developed.

A chair has no soul

The results of this thinking can be plotted in the progress of industrial design, from the crudely-decorated mass-produced products of the Great Exhibition in 1851 to the reduction of objects, furniture and architecture to their purest and most functional forms in the period of the Modern Movement. The Bauhaus of the 1920s under Walter Gropius ("each object," he said, "must fulfill its functions in a practical way and be long lasting, affordable and beautiful") and Le Corbusier's 1923 manifesto *Towards a New Architecture* ("all this humbug talked about the unique object, the precious 'piece' rings false and shows a pitiful lack of understanding of the needs of the present day: a chair is in no way a work of art; a chair has no soul; it is a machine for sitting in"), have remained the gospels of good design for generations. As recently as 1998, the design historian and cultural critic Stephen Bayley reinforced this position when he stated that "to be excellent, modern design requires the intelligent application of ideas to manufacturing industry." For him the cantilevered tubular steel chair designed by the Dutch architect and Bauhaus collaborator Mart Stam in 1924 remains "the irreducible minimum and unimprovable example of what a chair should be".

A culture of contemplation

But the world has changed a great deal since the time of Carlyle and of Stam and our views of industrial production with it. The work of psychoanalysts and anthropologists, historians and artists, has taught us that for a thing to be merely well made and functional is not always enough. Instead many people want objects which also reflect their desires and their aspirations, their personalities and even their cultural allegiances. In our pop-culture saturated age, many people would rather have a chair with an evocative name than an object reduced to a "machine for sitting in".

We live in an information age, bombarded with facts (news) and fantasy (advertising, film and games). We travel the world, invading other cultures and exchanging and assimilating ideas. National identities are no longer easily defined. Britishness has become a highly contested concept. At the same time it has become increasingly difficult to say what is good or bad, especially in the areas of cultural production. Only the very bold would dare to stand up and state in the authoritarian manner of Carlyle, Corb or Bayley what is right, what is wrong and what is moral.

Designers operating in this context do so as part of a new culture of contemplation. We look back and we look forward. We look at ourselves and we speculate. No longer, it is generally agreed, is there a place for manifestos which consider the needs of all human beings to be the same. Of this post-Bauhaus ethic, the design historian Gillian Naylor has written: "Its ideal of a universality was a myth and a mirage, shattered by war, politics and the demands of a consumer society. Today, no designer or design organisation could or would contemplate universal solutions to the problems of design for the real world".

So instead of reflecting a search for some universal truth or purely functional solution to the practical needs of people, the work of designers in *Lost and Found* (and this is true of

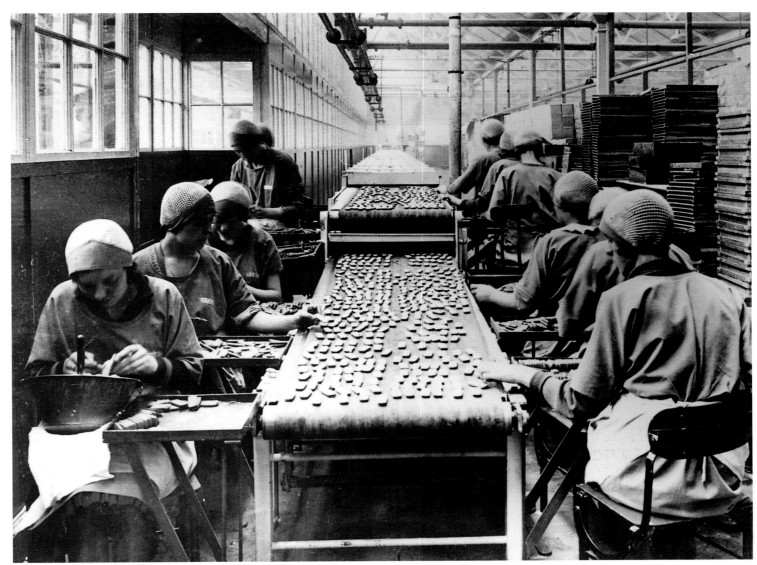

The age of industrialisation: this
photograph of the W&R Jacob biscuit
factory in Liverpool in 1926 celebrated the
possibilities offered by mass production.
Photograph: Hulton Getty

those in all the disciplines represented)
shows an attempt to engage with the history
of industrial production and human existence
in the complex conditions of late twentieth
century consumer society. Or in the words
of the Spanish architect and theorist Oriol
Bohigas, design is no longer merely about a
consideration of "the formal order of objects"
but also of "the disorder of men".

Representing chaos
All around us the air is infected with invisible
radio waves, the electromagnetic pulses given
out by appliances like computers, televisions
and telephones which are the support systems

of modern life. Dunne & Raby's 'Faraday chair'
is an enclosed chamber which protects its user
from these waves. It is a piece of furniture which
Mart Stam could never have envisaged. It is not
in production but would be easy to manufacture.
For its designers this is not as important as the
issues it raises.

The same is true of many of the three
dimensional designs in *Lost and Found*. Michael
Anastassiades' work, for example, is inspired
by the unpredictable, sometimes humorous,
often disturbing occurrences of everyday life.
His 'Alarm clock table' rocks gently at the time
set, overbalancing its contents to wake the
sleeper. The ambition in this prototype is for

richer possibilities than the merely functional. For IDEO, a design consultancy exploring the potential of digital radio technology, much of the interest is in how a product might respond to its user's personality. The result would be a mass produced product in the Bauhaus manner, but with inbuilt potential for each one to be different.

Our continued exploitation of natural resources and abuse of the environment in the process of manufacture – something hardly considered by the champions of the Modern Movement – has led many of today's designers to question society's need for more objects. Tord Boontje raises these issues in his work by recycling glass bottles as tableware and in his furniture which is made of discarded timber with blankets for upholstery. For JAM too, the multiple possibilities of objects already in mass production have provided inspiration for a number of products including vases made of lightbulbs, household goods in swimming float foam and stools fashioned from discarded television tubes.

The local versus the international
Designers of the Modern Movement largely rejected the emotional significance of local traditions or materials, working in the (often naïve) belief that the form, content and appeal of their work would be universal. Designers working in opposition to this view have promoted the value of local materials and processes as well as everyday experiences as inspiration. This is a position famously espoused by Victor Papanek in his seminal 60s book *Design for the Real World*. "All men are designers," he wrote. "Design is composing an epic poem, executing a mural, painting a masterpiece, writing a concerto. But design is also cleaning and reorganising a desk-drawer, pulling an impacted tooth, baking an apple pie, choosing sides for a back lot baseball game, and educating a child".

Designers like Michael Marriott and Konstantin Grcic delight in the simplicity and charm of everyday objects, often gathering them together and presenting them as new products with new uses. Thus Grcic's wardrobe appears like a bundle of broomsticks while Marriott's 'Bucket light' re-presents a familiar,

cheap and mass-produced object in a new and totally unexpected form. In Georg Baldele's work, too, the most prosaic things are transformed into objects of intrigue as a candle is wired up to become the poetically titled 'Fly candle, fly' or a coil of paper is extended to make a lamp. Wit and humour are not concepts which high-minded Bauhaus tutors would have considered appropriate in design. Instead such work reflects a pop sentiment of the kind expressed by Andy Warhol when he said: "The world fascinates me. It's so nice, whatever it is....I accept things. I'm just watching, observing the world."

For other designers working in Britain national identity is an important point of reference. Shin and Tomoko Azumi come from Japan, where cities are dense and space is at a premium. Their response has been to develop multifunctional furniture which takes up the least area but which provides the maximum potential for use. For the Spanish/Latin American trio of El Ultimo Grito, the materials and process of making the 'Miss Ramirez' chair draws on the Birkenstock shoe, a product which, despite its origins in Germany, seems to resonate with references to warmer climates. The chair is finished with suede which reminds designer Roberto Feo of the furniture of his Spanish childhood.

It would be wrong to suggest that the mass production of objects was no longer the ambition of many contemporary designers. There is still a great deal of validity attached by many practitioners and theorists to the idea of a well-conceived and affordable object with a utilitarian purpose. A number of designers in *Lost and Found* pursue this end. But Ross Lovegrove's garden light, Jasper Morrison's tray, Tom Dixon's chandelier and One Foot Taller's chair are all mass-produced items which contain more than the average amount of wit, charm or cultural references. The garden light is the result of a process transferred from the making of car headlights to create an object which refers back to a romantic lantern-lit past. For Jasper Morrison the seemingly utilitarian tray also embodies a historical reference to the role and culture of the butler. Meanwhile both Tom Dixon and One Foot Taller have made plastic products which, though produced

Left: Mart Stam's 1924 cantilevered steel chair remains for critic Stephen Bayley "the unimprovable example of what a chair should be". Tubular steel chair, designed by Mart Stam and made by Schorndorf, 1926. Victoria & Albert Museum, London/Bridgeman Art Library, London/New York.

Above: Le Corbusier's Villa Savoye, Poissy-sur-Seine, France,1929. Designed, in Le Corbusier's words, for the "fully motorized family", this shrine to Modernism was dismissed by Frank Lloyd Wright as "a box on stilts"

using industrial processes, proudly reveal the small flaws which make each one different.

Lost and Found

So what has been lost (or often willingly discarded) by all the designers in this exhibition is a belief in a universal solution. Instead, what is found is something more akin to a pre-industrial Romantic sensibility. The "I" has returned to the object and the creator again feels free to invest his or her work with the narrative of their lives, to give their products names and by doing so to suggest stories which we as users might then take up as fantasies. The result is not entirely a rejection of utopian Modernist ideals but more a natural development and a synthesis. So while designers are still committed to the idea of mass production and accessibility of objects, they are also determined to reinvest them with the soul which Le Corbusier so readily threw out.

Dunne and Raby

Anthony Dunne and Fiona Raby find
themselves in a slightly different
situation from some other designers
working in Britain today, as they are paid
to experiment with radical design ideas
without having the immediate pressure
of having to sell them to a manufacturer
in order to earn a living. As Research
Fellows at the Computer Related Design
department of the Royal College of Art,
Dunne and Raby are paid to explore
experimental ideas, and it is a situation
which has generated striking results.

After graduating from the RCA in
1988, Dunne and Raby moved to Japan
where they worked as industrial designer
and architect respectively. "We found that
in Japan, technology is absorbed into the
culture," says Fiona Raby, "whereas in
Britain no-one is interested." Tony Dunne
worked for the Sony Corporation alongside
150 other designers. He discovered that
the designers' role there was simply
to style the exterior packaging for the
electronic innards of televisions, radios
and cassette players, without having an
opportunity to influence the way the
appliances actually worked. In a move
which was part provocative and part
hopeful, Dunne proposed the 'Sony

Noiseman': a machine which, he argued,
would record and synthesize sounds from
around Tokyo, responding to the external
environment of its user rather than the
contents of a cassette or CD. Sony was
unimpressed, arguing that at best the
idea could be turned into a children's toy
("'My First Walkman'"), and Dunne quit
after a year to work as a freelance designer.
Fiona Raby, meanwhile, had found work
with the architect Kei-ichi Irie, designing
houses and exhibitions. In the process she
met architects such as Toyo Ito, with whom
Dunne and Raby subsequently collaborated
on the 'Visions of Japan' exhibition at the
Victoria and Albert Museum in London
in 1991.

This experience of Japanese cultural,
architectural and industrial practice
forms the basis for much of Dunne and
Raby's design work today. Concerned
with the sociological and personal effects
of the electronic revolution, Dunne and
Raby work on subversive products which
question perceived uses for consumer
goods, but which work in their own right.
One such product, the 'Faraday chair',
is an enclosed structure which acts as a
'Faraday cage', protecting the sitter from
bombardment by the invisible pollution
of radio waves from computers, radios and
telephones. It may not look comfortable,
but the 'Faraday chair' forces us to
question the meaning of privacy and
comfort in an age when it is impossible
to escape the effects of invisible
electronic signals.

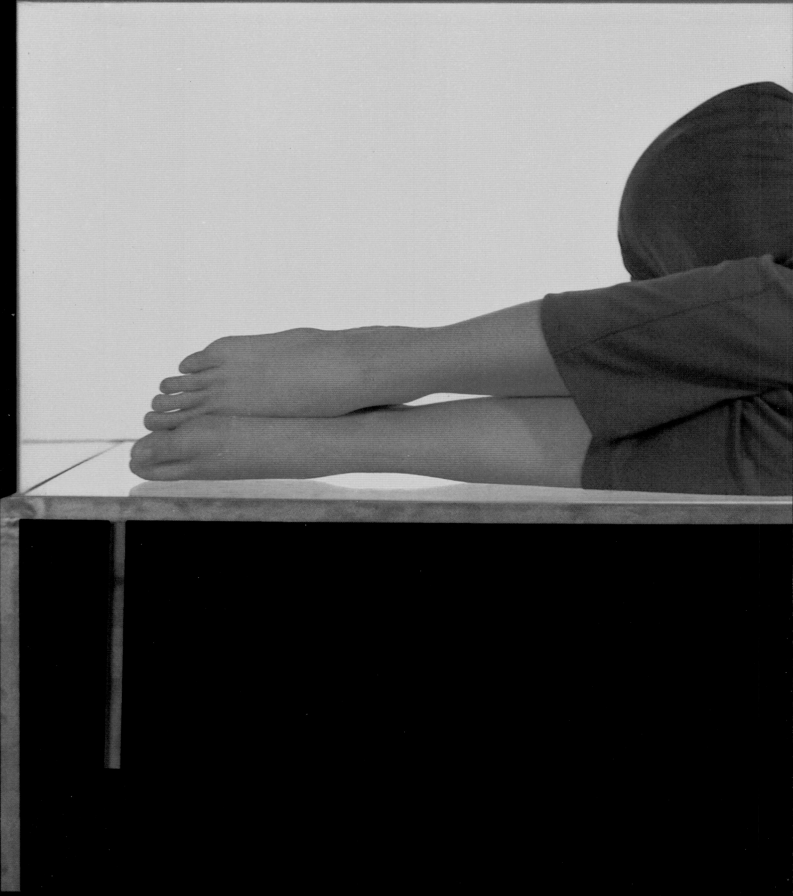

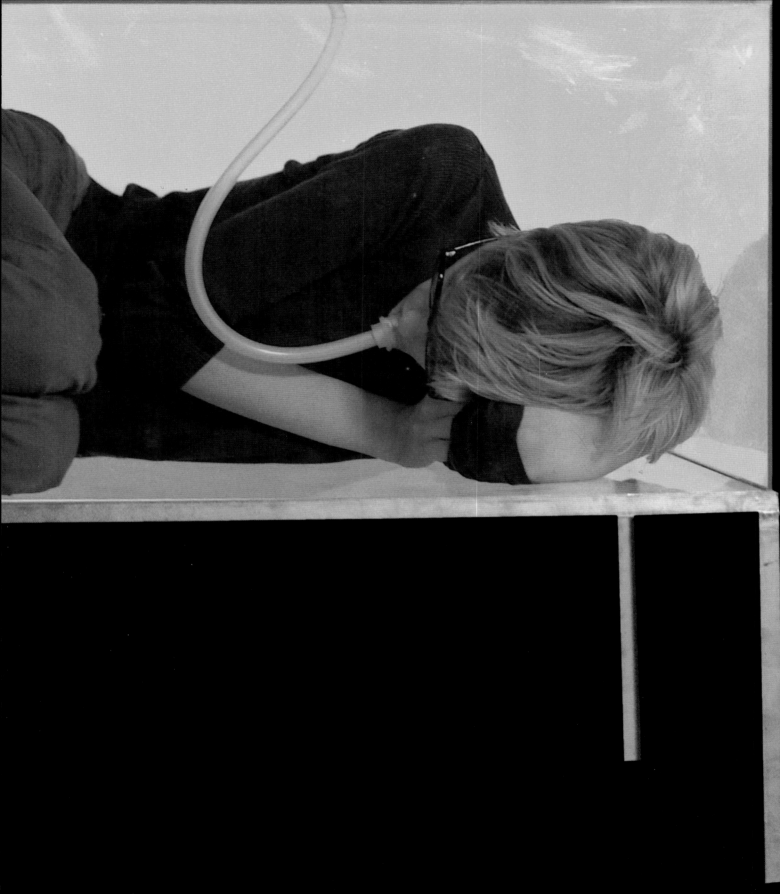

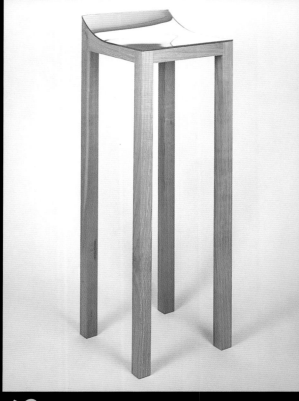

Michael Anastassiades

Born in Greece and educated in Cyprus, Anastassiades did not move to London until after finishing his military service. His ideas nevertheless sit comfortably within a peculiarly British vein of slapstick humour, building on the theory that the little accidents that happen in life, like spillages and objects falling off tables, can be funny as well as pathetic.

Anastassiades' work includes the 'Alarm clock table' [right], which vibrates silently rather than sounding a traditional alarm bell. In order to function properly, the alarm is dependent on objects being placed on its table top, which will then rattle or fall over when the alarm 'rings'. Normally, of course, when we are woken by a traditional alarm clock, the chances are that we will lunge into and knock over one of the items which is resting by the clock. This witty subversion of the accepted notion of a common household object – an alarm which causes havoc before we have a chance to wreak it ourselves – also suggests a more serious comment about functionalism. By creating a machine which does not work unless we offer it a sacrificial object which it can rattle or knock over, Anastassiades renders his alarm clock impotent without some planning by its user, and in doing so drives humanity between form and function. This human touch forces each table alarm clock to assume its own identity (depending on what is made available for it to rattle).

A sense of lost identity seems to have haunted Anastassiades throughout his life, and provides a useful clue to the reading of his design work. He studied Civil Engineering at London's Imperial College (he acknowledges the benefit it gave his design, but did not enjoy the experience), before moving straight to the Royal College of Art to take an MA in Industrial Design Engineering. Again, he was not happy, feeling that his ideas were not appreciated by the tutors. One such idea, the 'Talking cup' [below], almost resulted in Anastassiades failing the MA course. Drawing on his engineering skills, Anastassiades designed a plywood cup with a false bottom containing an electronic recording device which stored a spoken message when the cup was turned upside down, and replayed it to the cup's next user. "The external examiner was James Dyson," he says, "and he tore me apart when I presented it to him. He couldn't see why anyone would want to leave a message in a cup. He said 'it's not functional'." Cypriot culture, on the other hand, would make sense of the idea. There, a saying has it that if you want to hear the gossip, you must listen to your tea cup.

The formal qualities of Anastassiades' products and furniture suggest a seriousness which is in contrast to their humour. A recent range of furniture contained mirrors set into the backs of chairs and into the centre of a table [above left], a tragic hint that the loneliness of dining without a companion can be mitigated, or intensified, by seeing oneself reflected in the table or empty chair opposite.

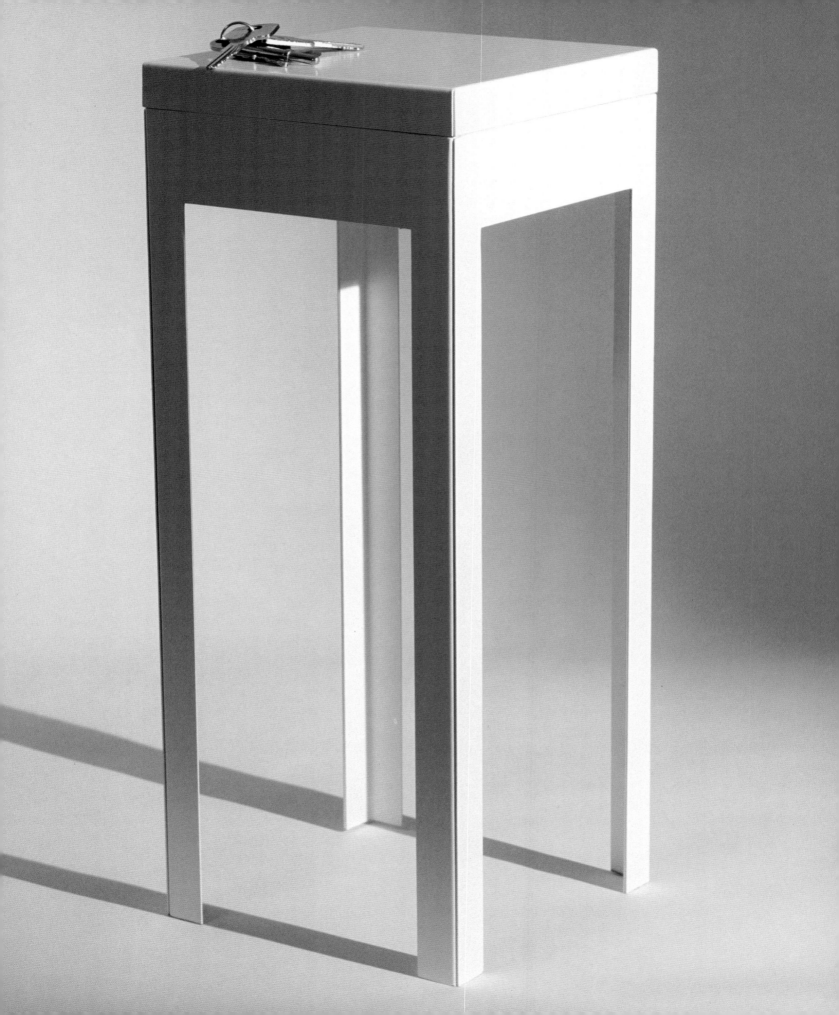

Left: 'Kiss communicator',
1998. Below: digital radios
produced as a project for the
BBC, 1997. Bottom right:
Macintosh helped bring
about the home-computer
revolution. Today, computers
are more often hidden inside
appliances

IDEO

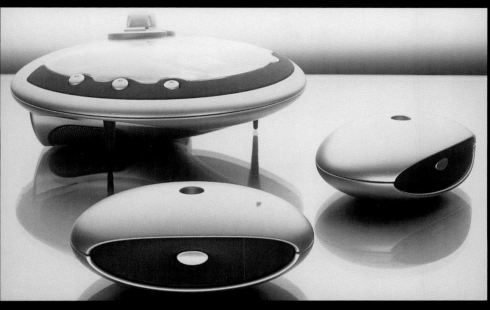

IDEO is unique among those selected for *Lost and Found* in that it is a multinational industrial design organisation with offices in London, Milan, Tokyo and throughout America. Its client list includes Royal Mail, Nike, Yamaha and the BBC, but this powerful corporate base has not prevented IDEO from conducting a series of experimental projects in pursuit of new approaches to product design.

Typical of such projects was a collaboration with two young graduates from the Computer Related Design department of the Royal College of Art, Nick Dormon and Tracey Currer, who worked for IDEO together with the BBC on a series of experimental products in 1997. Most important of the BBC commissions is a project to show the possible services of digital radio [above], enabling it to cater for the varying listening tastes of a family. IDEO's solution is a radio which stores the listening habits of each member of the family and reacts accordingly. It can record missed programmes and provide extra information (such as forthcoming sports fixtures) on an in-built screen.

IDEO's promotional literature explains the company's philosophy: "[Our work] celebrates an aesthetic that is more than the beauty of form, shape, proportion, colour and finish; it is informed by the design of electronic behaviours and the connected community of the Internet, adding experience, gesture and ritual to create an engaging smile."

Another project, also with a CRD graduate from the Royal College of Art, creates a product of apparent whimsy with a serious underlying message. Intrigued by the electronic exchange of emotions, Heather Martin and her collaborator Duncan Kerr have created the 'Kiss communicator' [left]: a hand held device which translates the air movements of a blown kiss into an electronic light pattern. The pattern is replayed on an identical machine to the recipient of the kiss, anywhere in the world, and once it has been played back, "like a touch on the arm," it is gone. The device also investigates a significant trend in electronic design: increasingly, sophisticated computers are embedded within appliances which do not offer a keyboard or screen as an interface. The 'Kiss communicator' playfully suggests one of the countless ways in which we are likely to interact with computers in future.

IDEO's work demonstrates that they are capable of significant innovation in a highly commercial and competitive market which, despite being at the forefront of technology has often been characterised by conservatism in its approach to design.

Tord Boontje was born and spent his childhood in the Netherlands, studying in Eindhoven before completing his training at the Royal College of Art in 1994. Boontje set up his company TranSglass in London together with artist Emma Woffenden. TranSglass is best known for its vases made from salvaged wine bottles, whose necks are then sliced off and the bottles sandblasted to form exquisite sculptural vessels. The process typifies Boontje's method of working. "I am interested in using everyday objects because they are close to people," he says.

Boontje's openness has resulted in collaborations with other designers, including fashion designers Shelley Fox and Alexander McQueen. "I did a collaborative design with Shelley for her show last year. It was a shoe for the models, with a simple willow sole. We got some inner tube patches and stapled them to the sole, and then screwed a little plastic disc on the top where the toe fits."

The result is like a wooden prototype of a flip-flop. Boontje has also been working on a range of products for Alexander McQueen to be produced by Japanese watch manufacturer Citizen, and launched in time for Christmas 1999.

Boontje's personal experiment, entitled 'Rough and ready' ("it's an attitude, as well as a furniture range") derives from his dissatisfaction with what he perceives to be the pretentiousness and inhumanity in design. 'Rough and ready' furniture employs rough-hewn, untreated timber screwed together and covered with a second-hand blanket which is taped to its wooden frame. "These are all materials which you could find in a skip" he says. "Too much energy is wasted in putting things together in contrived ways. The aim of this is to show that you can make a perfectly good chair by reutilising what exists already. And it's just as strong as any other chair."

Employing a tactic first used by ecology-conscious American designer Victor Papanek as part of the Good Form exhibition at the International Design Centre in Berlin in 1972, Boontje has prepared free do-it-yourself drawings to demonstrate that anyone can build a 'Rough and ready' chair – and that the designer himself is not seeking to profit from it. What makes Boontje's work unique, however, is his method of appropriating materials which others have already conceived of as junk, and then reconfiguring them as furniture which carries both a powerfully political message, and an acknowledgement that its aesthetic values are also of great importance to those who will use it.

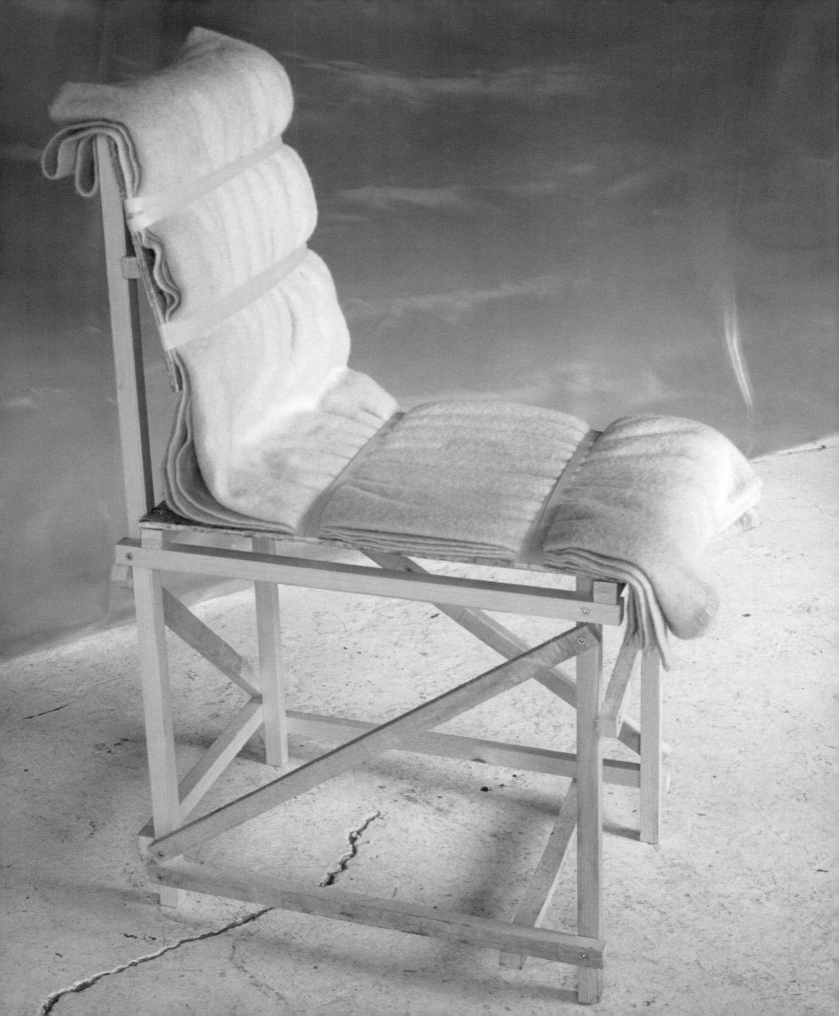

Below: 'Missed' daybed
for SCP, 1998. Below left:
W.H.Clark hardware shop
in London. Above right:
'Sardine can drawers',
1989. Below right:
'Bucket light', 1996

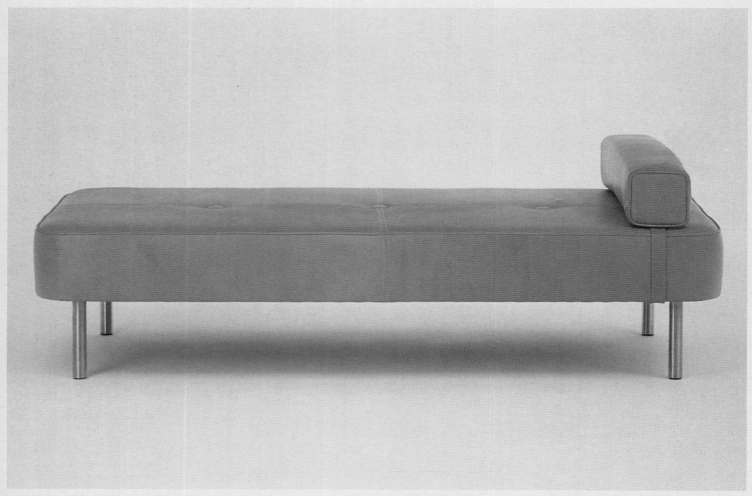

The rapturous applause which has greeted Michael Marriott since graduating from the Royal College of Art in 1993 has been in stark contrast to the limited volume of his design output. This imbalance says a great deal about the quality of Marriott's thinking, and the ease with which he is able to express it.

Speaking of his 'Bucket light' [right], which turns a simple builder's bucket on its head and transforms it into a lamp, Marriott says: "I chose a bucket because I like its immediacy and familiarity. The idea of making a hole in the bottom of the bucket – making it useless as a bucket – and putting the lightbulb through the hole was very appealing. I made the light by ruining the bucket. I don't see the bucket strictly as a found object though; I chose it deliberately from the builders' merchant because of its lovely colour. They also do a black bucket which is made from a lower-

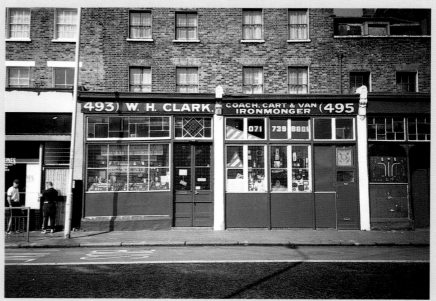

grade, recycled plastic and it is half the price, but the yellow one is much softer and it gives the quality of light I was looking for. It's like bananas and custard."

Marriott describes his approach variously as 'resourceful design', or 'ad-hocism' but much of his output also offers a homage to modernist and post-modernist design. His 'Missed' daybed [left], manufactured by his collaborator, the London-based furniture producer SCP, is a direct response to Mies van der Rohe's own classic daybed. "I'm surprised by how few of the design magazines have noticed the connection," says Marriott, "especially since it's called 'Missed'." Even so, the bed has its own character which is uniquely the domain of its designer. "The daybed reminds me of one of those old mattresses you might see in a skip and in my original design it is covered with an untreated leather. So if you spill something on it you might achieve that kind of stain in the middle which you always see on discarded mattresses." (SCP also offers the bed in an upholstered version for those purchasers who don't want to share Marriott's joke).

Michael Marriott is best known for his charm and his thousand-watt grin, but he is keen to emphasise the serious side of his practice. As well as utilising materials (sardine cans, wooden spoons, orange packing crates) which were originally designed for other purposes, he is also fascinated by the geometry of brutalism. "In some ways I am more of a modernist than Mies van der Rohe," he says, citing the simple planes of his tiny sardine-can drawer unit [above right]. Once its empty sardine can drawers are removed, one sees the brutal simplicity of the wooden frame. And although the wing nut handles are a jokey reference to fish tails, the result is, for Marriott, entirely functional.

Top: Grcic's studio. Below:
'Es' shelves, 1999. Right:
'Hut ab' hatstand, 1998

Konstantin Grcic

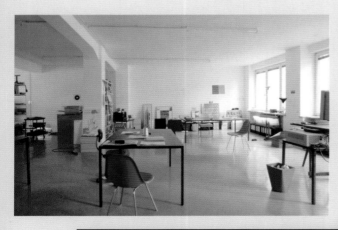

Known for his ability to find a fresh angle on familiar objects, Konstantin Grcic mixes elegance with pragmatism. Though now based back in his home town of Munich, Grcic is another internationally successful graduate of the Royal College of Art's furniture department. He graduated from the RCA in 1990 having attended Parnham College between 1985 and 1987, where he learned traditional craftsman's skills.

Grcic first worked with Sheridan Coakley at British manufacturer SCP, and has subsequently produced designs for a number of European companies with what he desribes as "visionary personalities" at the helm. These designs include the 'Mayday' lamp for Flos, a typically well thought through and charming take on a mechanic's inspection light, and a waste paper bin and a bucket for Authentics, the plastics company which proves that affordable household basics can also be examples of good design. The 'Hut ab' ('Hats off') coat rack is a collaboration between Grcic and German manufacturer Nils Holger Moorman. Like the shelving system Grcic recently designed for the company, the hatstand seems to be the result of a bundle of sticks being picked up and nailed together. It is, however, a functional item of furniture which eschews accepted ideas about storage and enclosure, stripping down the form of the wardrobe to its bare essentials.

Grcic is the epitome of the designer whose working process departs from ideas rather than function. "I'm not one of those people who can work on a train or a plane", he says. "I need to be in my studio, surrounded by my books, models and objects. I'm not a collector, it's more a library of items and materials that I have consciously accumulated and ordered, even if that order is not linear." Grcic's interest in other disciplines, particularly fine art, as well as the way he engages with the history of art and design are important elements of his considered and intensive approach.

Grcic's work is characterised by an openness to new possibilities and an avoidance of obvious solutions. (One of his latest projects was an installation of oversized clocks for a station in London's Canary Wharf.) Some pieces are the result of a complex, theoretical process, others are playful and full of humour, while the materials and processes used are as likely to exploit the latest technological developments as the most primitive basics. He enjoys the freedom from boundaries offered by the contradictory nature of design: "There are no rules, no methods or templates to follow. On the contrary, you have to keep revising and reviewing your approach. That's something I manipulate very consciously. With every project, you start right back at the beginning. I never know how I am going to tackle a project; I never know what the result will be right until the end."

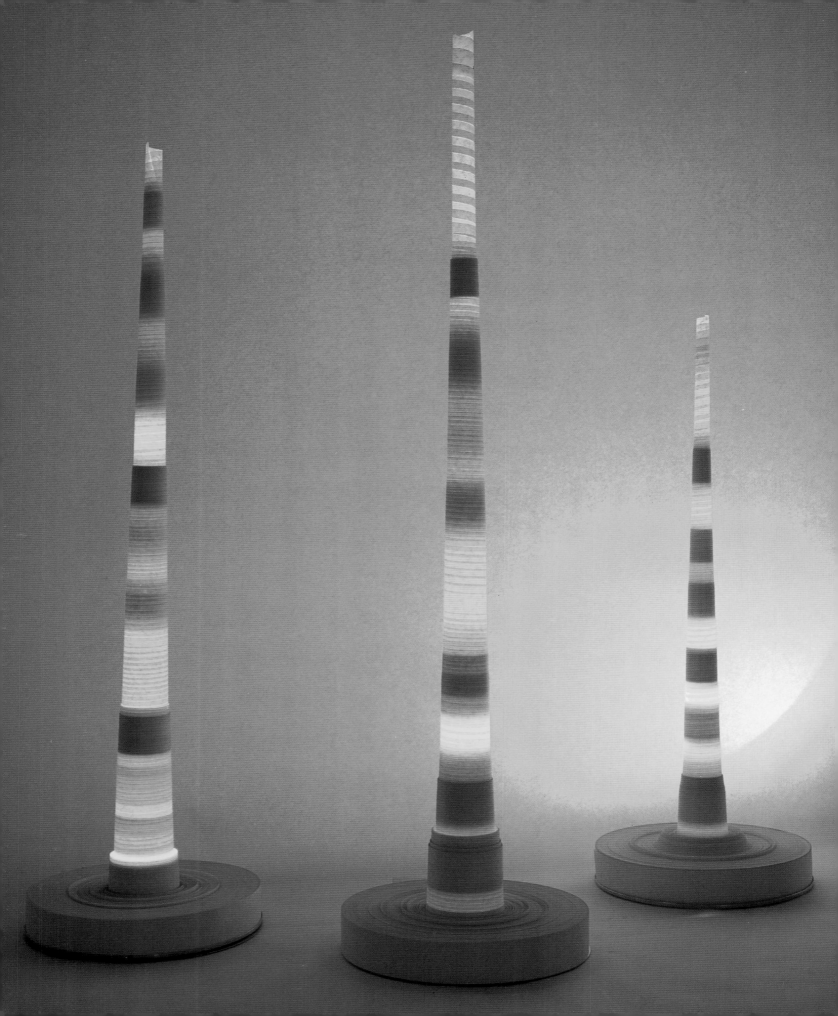

Left: 'Stalagmite' paper
tape lights, 1998. Below
clockwise from top:
'Wellington boot light',
1996; 'Fly candle, fly',
1997; tailor's tape measure

Georg **Baldele**

Georg Baldele completed his studies less than a year ago. Having trained for five years (between the ages of 15 and 20) to become a mechanical engineer, he studied for a further five years under the tutelage of architect and furniture designer Ron Arad in Vienna, before taking his MA at the Royal College of Art (by coincidence following in the steps of the newly appointed Professor of Furniture Design, Ron Arad) in 1997.

The link with Arad was to prove significant. In 1995, Arad introduced Baldele to the British designer Michael Marriott, and the meeting resulted in the jointly-designed 'Wellington boot light' [left], a typical example of the resourceful approach both designers have continued to take.

Baldele's work is characterised by an interest in capturing and expressing the materiality of light. While studying in Vienna he experimented with candles, the most immaterial of light sources. This led to 'Fly candle, fly' [left], a simple candle hanging from an almost invisible tungsten wire, appearing at first glance to float magically above the ground and breathtaking in its simplicity. Ron Arad was intrigued by the idea embodied by this project, and introduced Baldele to the internationally renowned lighting designer Ingo Maurer, who immediately offered to help Baldele develop 'Fly candle, fly' commercially. In January 1997, as part of the Cologne Furniture Fair Baldele's candles featured in an extraordinary lighting installation by Ingo Maurer situated in a hidden tunnel inside Cologne's main road bridge across the river Rhein. Baldele's work became famous throughout the design world as a result.

Georg Baldele's most recent lighting designs are inspired by the coiling of a tailor's fabric tape measure. The lights [far left] consist of fire-resistant paper coiled into spools which can be up to 500 metres long. By drawing the paper out of the centre of the spool, it is made to stand up and form a lightshade. Because of the refractive properties of the paper, when a halogen light is placed in the centre of the spool its beam is deflected outwards, throwing out an exquisitely subtle glow whose intensity is dependent on how far out of the spool the paper coil is drawn.

Left: Japanese Butoh
dancer, Sankai Juku
company. Photograph
by Birgit. Below: 'Table=
chest', 1995. Top right:
'Chair/table', 1997.
Bottom right: screen
and cupboard, 1995

Since graduating from the Royal
College of Art in 1994, Shin and Tomoko
Azumi have appeared with extraordinary
frequency in the British design press,
offering a charming alternative to the
laddish image of the trendy Hoxton-
based design crowd. The Azumis,
however, are not outsiders: because
their work has received so much attention
in the media, it has been the inspiration
for many design students, as well as
precipitating an entire exhibition,
'Flexible furniture', at the Crafts Council
in 1997. Their diligent, thoughtful
approach has led to commissions for
mass-production furniture from Italian
manufacturers LaPalma.

Shin and Tomoko Azumi were born
in Kobe and Hiroshima respectively,
and first met on a Foundation course
in Japan, where they discovered a
mutual interest in theatre. Both shared
a fascination for Butoh dancing, a
Japanese dance style developed in the
1960s and 1970s in response to the
modern American dance techniques
pioneered by Merce Cunningham. A fusion
of Eastern and Western influences, Butoh
dancing celebrates the beauty of human
movement in daily life. "One example is
'Min Tanaka'," explains Shin, "which is
a dance movement which starts with the
motion of a Japanese farmer hoeing in
his field. Then, suddenly, as the farmer
is in the middle of this motion, he notices
the sun setting and looks up. 'Min Tanaka'
is a stylisation of that moment."

The Azumis' furniture designs make clear references to Butoh dancing: motion and transformation are a key part of many of their pieces, including 'Table=chest' [left], a chest which unfolds ingeniously to become a low table. "It is about the interaction between object and people," says Tomoko, "but the really interesting part is about the articulation of movement; the moment of transformation from one form to another. We wanted to design that moment."

Before moving to Britain, Shin worked as a commercial product designer while Tomoko worked for an architecture practice in Japan. Both, however, felt the need to work more creatively. "We wanted to do our own thing and not be driven by a marketing strategy, and Japanese design didn't allow us to do that. Also, furniture – and design in general – is very much a Western thing. There is no tradition of furniture in Japan."

The Azumis' designs are influenced by life in Tokyo and the lack of space which is so much a part of the experience of the city. They are also, however, careful to acknowledge European cultural references: "Like the Modernists, we start by thinking about an object and its materiality. But what makes us think about it differently is the immateriality which surrounds it."

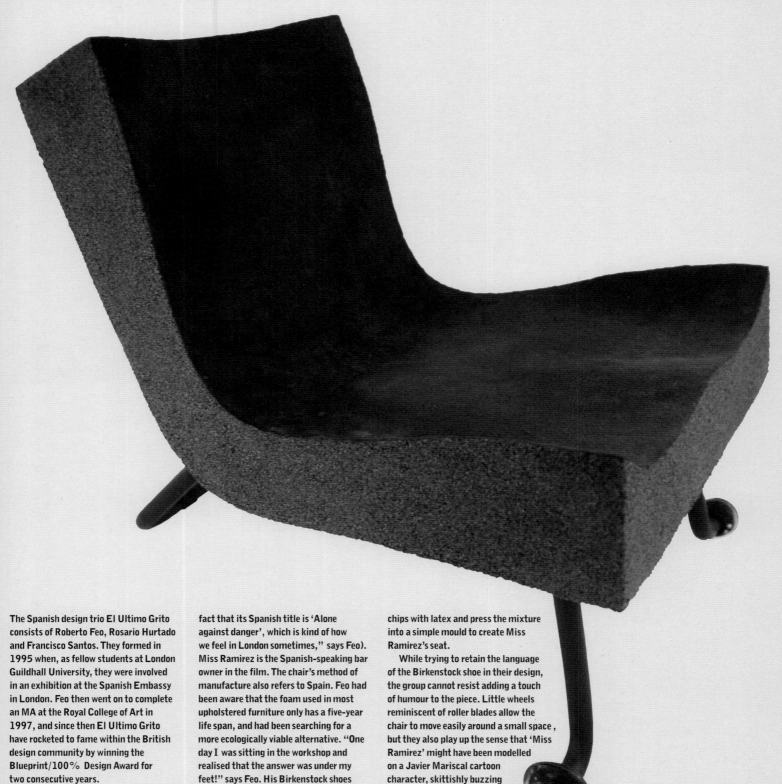

The Spanish design trio El Ultimo Grito consists of Roberto Feo, Rosario Hurtado and Francisco Santos. They formed in 1995 when, as fellow students at London Guildhall University, they were involved in an exhibition at the Spanish Embassy in London. Feo then went on to complete an MA at the Royal College of Art in 1997, and since then El Ultimo Grito have rocketed to fame within the British design community by winning the Blueprint/100% Design Award for two consecutive years.

Roberto Feo is in no doubt about the group's influences: "Spanish design is very traditional – we think of our work as British or European. We probably have more in common with Droog (the Dutch design group) than anyone else", he stated in a recent magazine interview. Yet the group's work is also characterised by unambiguous references to their home country.

The 'Miss Ramirez' cork chair [above] derives its name from one of Feo's favourite films, High Noon ("I love the

fact that its Spanish title is 'Alone against danger', which is kind of how we feel in London sometimes," says Feo). Miss Ramirez is the Spanish-speaking bar owner in the film. The chair's method of manufacture also refers to Spain. Feo had been aware that the foam used in most upholstered furniture only has a five-year life span, and had been searching for a more ecologically viable alternative. "One day I was sitting in the workshop and realised that the answer was under my feet!" says Feo. His Birkenstock shoes used a trademark moulded cork sole, and Feo unashamedly borrowed the idea. Although Birkenstock shoes are a product of Germany, Feo discovered that the cork chips used in their manufacture derive from the waste products of Spain's cork industry. "Most of the cork bark grown in Spain is used for making wine bottle stoppers," he explains, "but to make those round corks they have to cut off lots of pieces, and you can buy big bags full of these chippings really cheaply from Spain." El Ultimo Grito mix the cork

chips with latex and press the mixture into a simple mould to create Miss Ramirez's seat.

While trying to retain the language of the Birkenstock shoe in their design, the group cannot resist adding a touch of humour to the piece. Little wheels reminiscent of roller blades allow the chair to move easily around a small space , but they also play up the sense that 'Miss Ramirez' might have been modelled on a Javier Mariscal cartoon character, skittishly buzzing around on its wheels. References to weird sci-fi films and Spanish comics litter a conversation with Feo, as does his wry sense of humour. "I am influenced by the Japanese approach to seating," he says. "The lower you sit, the more space you feel above your head."

Left: 'Miss Ramirez',
1997. Right, clockwise
from top: 'Don't run, we
are your friends', 1998;
'El señor del caballito' (the
man with the little horse),
by Spanish designer
Javier Mariscal, 1970;
Birkenstock shoe

El Ultimo Grito

Ross Lovegrove was born in Wales and first began designing when he was 16 years old. He graduated from Manchester Polytechnic in 1980 and went on to complete an MA at the Royal College of Art in 1983. He attributes some of his success to what he calls the 'working class phenomenon', (getting out of the rut) and to design history. He believes it is important to know where an idea comes from and the thinking around it. Only by having an understanding of the basics can you know whether something is a fresh idea or not. "Design is my passion, I don't play any sports or have any hobbies, I think about design 24 hours a day" he said in a recent interview with *Blueprint*.

In the early 1980s Lovegrove moved to Germany where he worked for the international industrial design company Frog Design, but left when he became disillusioned with what he describes as the "formalist" nature of the work. "I began to feel vacuous. There is more to life than an office with a swimming pool". Lovegrove moved to Paris where he worked for the furniture manufacturer Knoll International. It was a move which resulted in Lovegrove meeting some of the world's best-respected designers. By the mid-1980s Lovegrove himself had gained recognition in Europe and along with designer Phillipe Starck and architect Jean Nouvel was invited to join the prestigious Atelier de Nîmes.

Now back in Britain, he works at his studio in Notting Hill mixing 1960s cultural references such as the bohemian styles of the fabled London fashion store Biba, with organic, often anthropomorphic forms to produce furniture which makes ergonomic and ecological sense. Of his influences he says that he lives and works in a particular

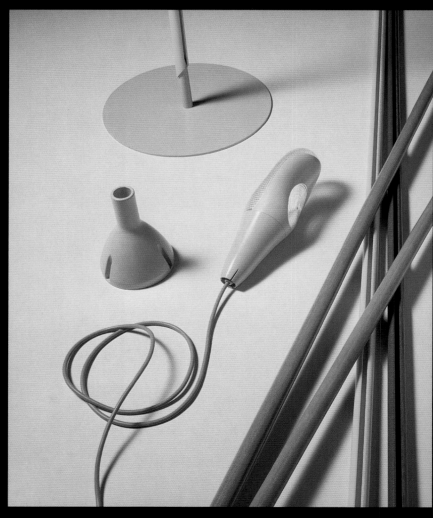

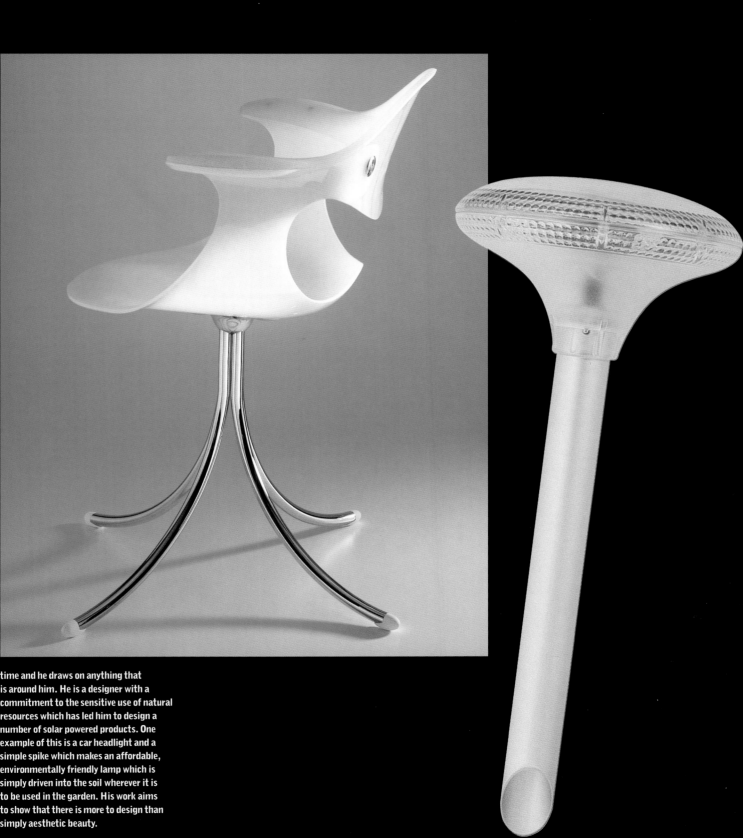

Top left: design for a
small car, 1997; Bottom
left: 'Solar bud' lights for
Luceplan, 1998. Below:
'Bluebelle' chair for
Driade, 1998, light for
Luceplan, 1998

time and he draws on anything that
is around him. He is a designer with a
commitment to the sensitive use of natural
resources which has led him to design a
number of solar powered products. One
example of this is a car headlight and a
simple spike which makes an affordable,
environmentally friendly lamp which is
simply driven into the soil wherever it is
to be used in the garden. His work aims
to show that there is more to design than
simply aesthetic beauty.

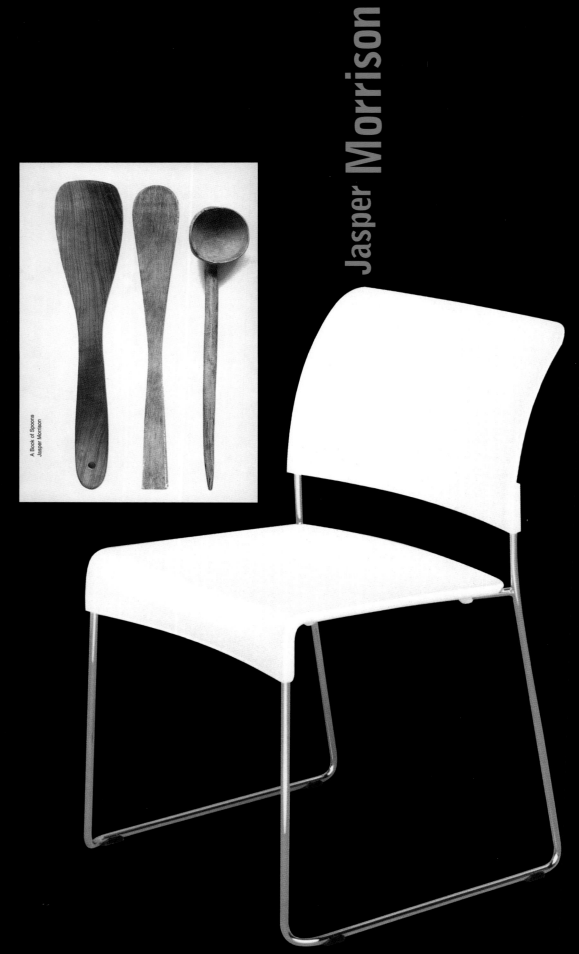

A Book of Spoons
Jasper Morrison

"You should feel a sympathy for the objects you live with and not have them showing you an unattainable perfection which your own character can't live up to," said Jasper Morrison in an interview with the contemporary art magazine *Frieze* in 1991. It is an approach which has been so popular that Morrison has since become one of Britain's most successful industrial design exports, with wide-ranging commissions including a entirely new tram for the city of Hanover, door handles for the German manufacturer FSB, and a popular plastic wine rack [right] for Magis.

Morrison studied furniture design at the Royal College of Art, graduating in 1985. The 'Thinking man's chair', an early piece made for an exhibition in Japan, was a clear example of Morrison's sophisticated style. The looping curves of the chair had their dimensions written on them in white lettering. "Since it was going to Japan I thought 'They love to copy. Why not put the dimensions on? At least they'll get it right'."

Drawing on the language of European Modernism, Jasper Morrison refines ideas and form down to their essential qualities, imbuing his products in the process with a subtle wit. His designs display a sophisticated understanding of the inherent qualities of materials and their function – and then betray a quiet soulfulness which takes them beyond the realms of the Modern project. Often, his designs are reminiscent of notions of comfort, aesthetics and functionality which were popular in the 1940s and 1950s.

Recently Morrison completed a personal publishing project with the graphic designer Paul Elliman. *A Book of Spoons* contains, as its title suggests, a series of black and white photographs of spoons from different cultures [above]. Simple though it may seem, the book's structure raises a powerful question: which way up should we look at a spoon? Should it be portrayed with its bowl facing up, or down? The book resolves the conundrum by employing another: turn it upside down and the book reveals another cover on the back. The book can be read equally easily in either direction, with the spoons facing up or down depending on the reader's preference. Whimsical though it may sound, this elegant

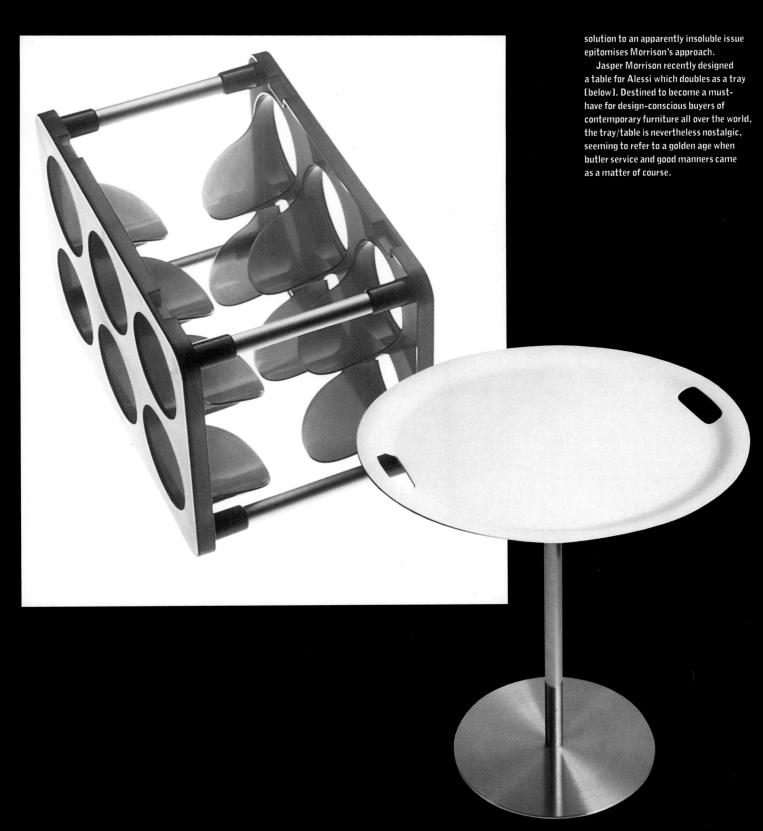

solution to an apparently insoluble issue epitomises Morrison's approach.

Jasper Morrison recently designed a table for Alessi which doubles as a tray [below]. Destined to become a must-have for design-conscious buyers of contemporary furniture all over the world, the tray/table is nevertheless nostalgic, seeming to refer to a golden age when butler service and good manners came as a matter of course.

Below left: 'Jack light',
1996; Below: street
bollards. Photograph by
Martin Parr. Right: Tom
Dixon with 'Star lamp',
1997

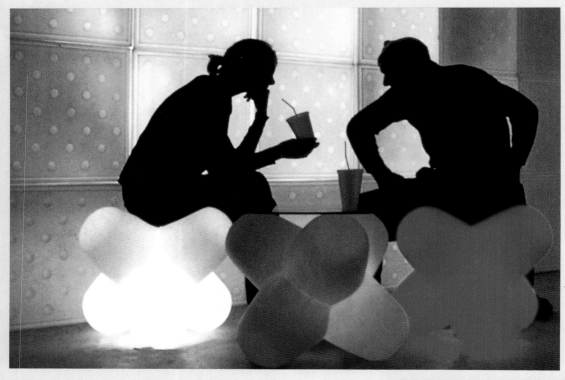

Tom **Dixon**

Widely exhibited in Europe, and regularly celebrated in the British design press, Tom Dixon's influence on British design has been considerable. His association with British architect Nigel Coates in the 1980s, and his initial interest in designing and making furniture using discarded scrap metal, led him (along with another great influence on today's designers, Ron Arad) to be grouped with designers who were better known for one-off furniture rather than mass produced objects. Dixon has always, however, been equally interested in the possibility of large-scale production – a fact which contributed to his appointment in 1996 as Head of Design for the furniture and interiors store Habitat.

During the 1990s Dixon went through a difficult period when his own furniture retailing company Space struggled to make ends meet. Partly as a result of such commercial necessities, Dixon's interest in mass-production led to a fascination with the possibilities inherent in moulded plastic, which he has explored through a new company, Eurolounge.

The shape of the 'Star light' [right] like many of Tom Dixon's other recent moulded plastic pieces, is reminiscent of the simple spiky forms commonly found in rubber balls or children's toys. It was designed by fitting together a number of cheap polystyrene cups. When Dixon was happy with the way it looked, he employed the simplest of manufacturing technologies for its mass-production: a rotation moulding technique originally developed by Easter egg manufacturers in order to make their chocolate eggs hollow. Rotation moulding is also used to make the British street bollards [right] which are lit internally, and in fact Dixon's first designs in this plastic medium consisted of a chair/light made from one of these traffic bollards with its trademark yellow and blue colourings intact.

Dixon has appropriated the technique for the manufacture of mass-produced furniture, but is particularly keen on the process because, due to the lack of control inherent in it, each finished product contains many of the flaws and imperfections of the one-off. "I want to make things which everyone can afford," he says, "things which are commercially successful."

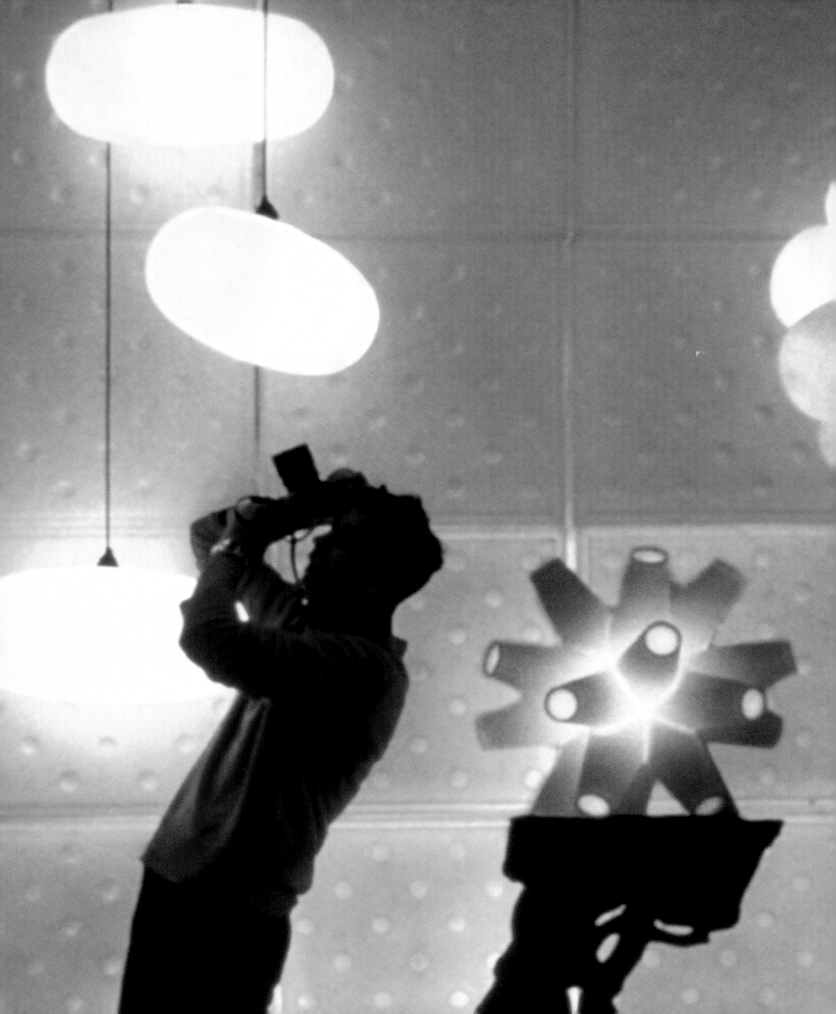

Above left and right :
'Chasm' chair, 1998.
Below left: One Foot
Taller's studio in Glasgow
doubles as White's home.
Photographs by Alan
Dimmick

One Foot Taller

Trained at the Glasgow School of Art, Will White and Katarina Barac formed One Foot Taller immediately after graduating. The name refers to the fact that White is one foot taller than Barac.

One Foot Taller's studio space provides a powerful context for their work. Situated on the second floor of a traditional stone-built Glasgow tenement, the studio is, more or less, based in Will White's kitchen. There, the dining table is piled high with production pieces, prototypes, papers and several bowls full of hooks, switches, joints and other bits and bobs which the duo have collected. Drawers overflow with more stuff. Other parts of White's apartment have the same feeling of chaotic overflow: the bathroom has objects of interest hung on the wall by the sink – and yet both White and Barac seem to be operating a mutually-negotiated system.

One Foot Taller, benefitting from a grant from Glasgow's City of Architecture and Design 1999, have worked in collaboration with Andy Harrold, owner of the Glasgow-based furniture retailer Nice House, to develop a moulded plastic chair which promises to take their practice in new directions. "We are interested in moulding techniques," says White, "and this project gave us the chance to spend some time developing a rotation-moulded chair which might otherwise have been impossible for us to afford." The idea behind the chair, however, is the outstanding part. One Foot Taller designed a rotation moulded plastic piece with two central legs which, like all such moulded items, is hollow. They then cut this piece in half through its centre, and bolt the two sawn halves back together with their hollowed-out innards facing outwards. In doing so they create a lightweight, four-legged chair called 'Chasm'. "We had some production difficulties," says White, "because when it first comes out of the mould, the chair is really strong. But when you cut it in half, a lot of the strength is lost." Barac and White have countered the problem by manipulating the thickness of the plastic during the moulding process.

Although some of One Foot Taller's earlier work was made from salvaged materials, they now distance themselves from other groups who have used a similar working method. "Re-using old materials does not particularly interest us," says Barac. "We want to manufacture well-designed objects using the best materials we can get our hands on."

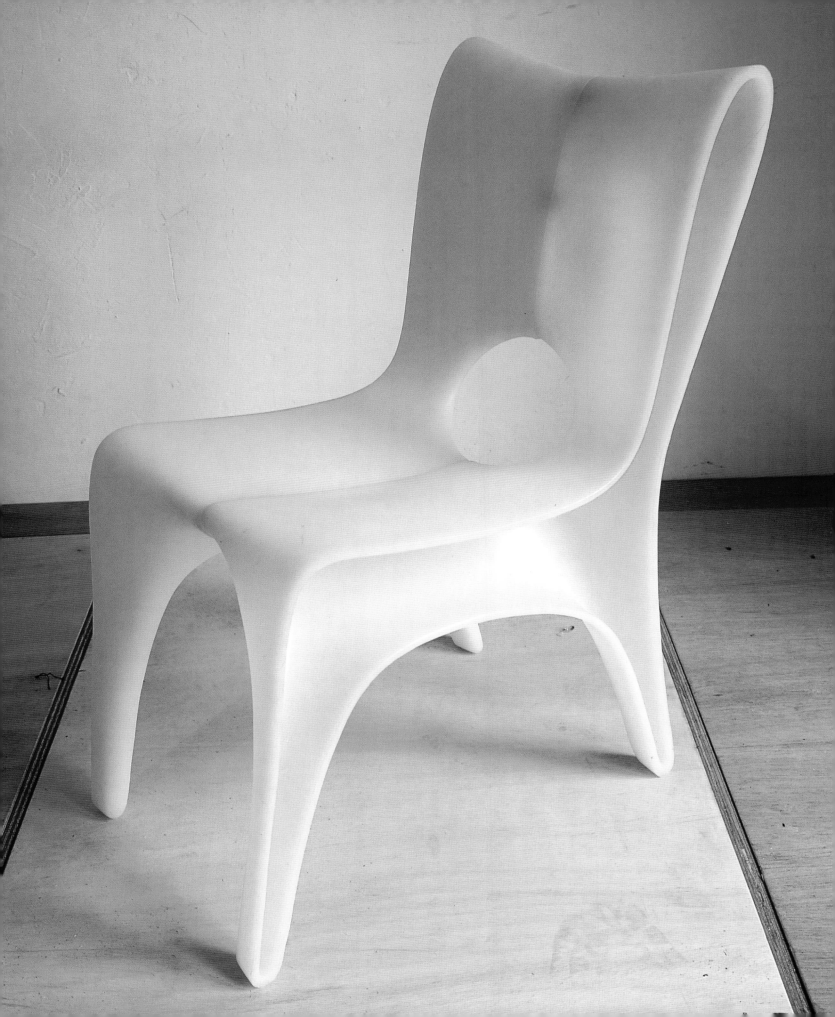

Mark Bond

Although Mark Bond does not readily admit to any clearly articulated project within his design, his research has followed a line of investigation which has continued to influence his practice. After graduating from Ravensbourne College of Art and Design in 1989, Bond worked for a commercial furniture designer for three years. When the recession struck Britain in 1992 and he found himself out of work, Bond signed up for an MA at the Royal College of Art. There, he was taught by the industrial designer Sebastian Conran, whose "obsession with gadgets" and "amazing ideas" appealed to Bond.

Encouraged by Conran's approach, Bond embarked on a search for what he calls "pure functionalism". The search led him to study military designs such as the Stealth Bomber and the Apache attack helicopter ("it's so ugly, it's fantastic") [left]. He soon realised that his search would be fruitless: "whatever I found, I realised that the design wasn't just functional. It was also giving out a particular message. Like the Stealth Bomber. It's designed to look sinister."

At first sight, the curvaceous contours of Mark Bond's 'Rubber lamp' [right] suggest a designer experimenting with images of sex and sensuality. "Not so!" he proclaims. On second glance, we see that the light hangs from a simple wooden peg in a manner reminiscent of the drip which dispenses essential fluids into the bloodstream of hospital patients. Then we notice that the stretched rubber allows light to pass through it so as to make it seem like skin lit from below by a torch – some hints that Bond may be interested in medical or biological imagery. But again, "not especially," says Bond. "I was just trying to design an affordable light for Habitat. In order to make it as cheap as possible, I wanted to do away with that metal piece which most lightshades have to use to keep the shade a safe distance from the bulb. The idea of the rubber was to make a light which only needed two working pieces: one bulb, and one shade. It seemed like such a simple idea, but it took me several years to find a rubber which was sufficiently heat resistant to pass all the tests."

In talking about the 'Rubber lamp', Mark Bond seems to be gently playing on his ideal of 'pure functionalism', while also acknowledging the inevitability of his aesthetic and conceptual choices as designer. The choice of rubber was, he argues, made on the basis of function, as it was the only material which would cope with the heat. But the colour? "Well, I wanted it to make a statement, but in a quiet way, so I chose red, orange or white." And the wooden peg? "It started with the idea of those lights you get for working under a car bonnet in the dark: you hang them from the bonnet with a little hook, and move them around really easily. But in the end, after a lot of tests, I decided to go for one simple peg. It looks better."

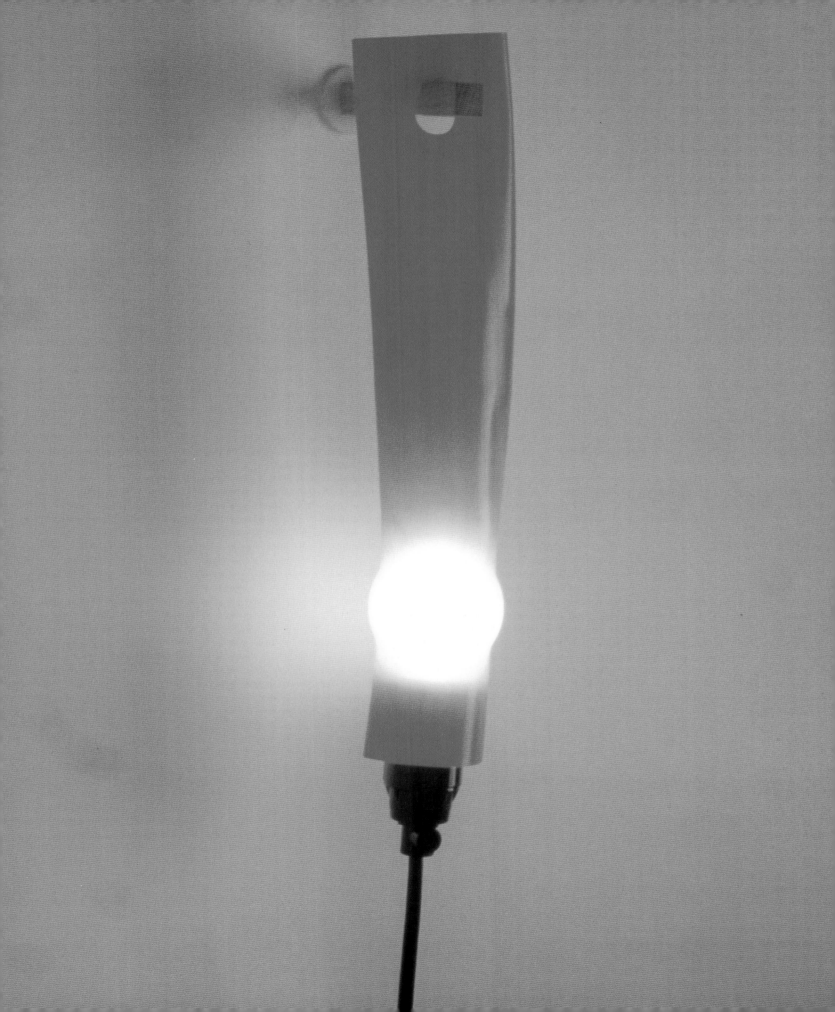

Above left: the garden
gnome, a kitsch symbol
of English suburban pride.
Bottom: 'Table lamp',
1996. Right: 'Star vase',
1997

Nick Crosbie graduated from the Royal College of Art in 1995 and launched Inflate together with designers Michael and Marc Sodeau, achieving notoriety almost immediately with a much-publicised inflatable vase. Over the following years Inflate experimented with the possibilities of the inflatable form, from egg cups to chairs, with enormous success.

Crosbie's upbringing – extraordinary perhaps only in its ordinariness – has clearly had a profound effect on his attitudes and work. Born in Middlesex in 1971, Crosbie lived there until 1980 when his family moved to nearby Buckinghamshire, where they have lived ever since. "I had a stable childhood… you know, a sister, a dog…," he says, "and I was one of those Lego kids. I spent my time building Lego trains and oil rigs."

Crosbie and the Sodeau brothers conceived the idea for Inflate while Crosbie was studying at St Martins in London between 1990 and 1993. He claims that his two-year stint at the Royal College of Art consisted mainly of developing the Inflate concept and preparing himself for its launch, although he also acknowledges the lasting influence of his tutor Daniel Weil.

Unlike other designers using inflatable material, Crosbie is fascinated with manufacturing processes, and in particular with a desire to produce objects for a wide audience which are normally available only to an affluent, design-literate public. "I have this romantic idea that I should be able to manufacture in England," he says, "although I have recently had to accept that it's impossible to keep doing it when the competition arrives with cheaper products." His passion for mass production at reasonable prices has led him to experiment with different mass-production processes for plastics, such as dip-moulding, the process used for the manufacture of rubber gloves. Inflate commissioned a number of designers including Michael Marriott to design small objects for manufacture using the dip-moulding process, and Crosbie is keen to point out that such collaborations are a way of keeping the company alive with ideas and fresh approaches.

Most recently, however, Crosbie and his team have focused again on the inflatable materials with which they began and are investigating the possibilities of an architectural system consisting of inflatable walls. A long-term project with Expo 2001 in Switzerland promises to yield a modular system using concrete bases and pneumatically inflated structures, and the winner of the 1999 Concept House project (a competition encouraging experimental ideas for low-cost housing) as part of London's Ideal Home Exhibition, features an Inflate wall ascending majestically from over its front door.

Urban fabrications

True to its name, nothing is authentic about Fake London. Its Spanish designer Desirée Mejer, although conceived in the Dorchester Hotel in London, only moved to Britain from Spain in 1992. Her first collections included camouflage copies of Chanel suits and since then she has adapted all the picture-postcard imagery of tourist London: the Union Jack, the Queen's head, a bull terrier. Secondhand cashmere is washed, cut up and re-sewn into Union Jack jumpers in camel and plum, black and white, or Rasta colours, with seams reversed.

The Union Jack in Rasta colours reflects the hybridity of the real London, like Owen Gaster's trouser suit in Prince of Wales check with rainbow spray painting which combines traditional tailoring with urban grafitti. Earlier collections were inspired by ragga fashions around his East London studio in Dalston. His work is sleek, edgy and streetwise, like the Londoners who inspire him, fusing the traditional East-enders' love of sharp dressing with the vibrancy of black urban subcultures in the late twentieth century.

"You put up a surveillance camera – I'll put up a collar." Vexed Generation's ballistic parka, in knife-, and fire-proof nylon, highlights the erosion of civil liberties in the 1998 Crime and Disorder Act which, among other things, made it illegal to hide one's face in a demonstration. If increased surveillance and police powers of arrest have helped to erode community and breed paranoia in the 1990s, Vexed Generation's agitprop streetwear simultaneously communicates these issues and protects their wearers from their worst effects. Beneath the turned up collar is an anti-pollution face mask. Highlighting social and political questions, the Vexed designers respond to their own experience of London street life in the 1990s: surveillance (a hood that conceals the face), the environment (a sleeve pocket for an anti-pollution mask), the quick-change (a skirt that zips into a pair of trousers).

Fake London lovingly perpetuates some great British fictions. Owen Gaster celebrates urban verve. Vexed Generation highlights the hazards of city life. These competing narratives sketch a complex and multi-faceted

city, a London not generally represented in its image as a centre of fashion.[1] Here luxury and poverty rub shoulders in parallel worlds. Neither Albion nor William Blake's green and pleasant land, contemporary Britain is layered, and between the layers interesting things happen. In these interstices a number of designers have found a symbolic space in which to work, echoing the spaces between the cracks in the pavement, invisible until you get your eye in, and then you wonder how you could have missed them. Hussein Chalayan's collection *Between* was shown in Brick Lane, in London's East End, a hinterland between prosperous London (the West End and the City) and the ghastly optimism of Docklands and the Millennium Dome. To reach it, the fashion pack traversed streets thronged with the local celebrants of a Muslim festival to see a show which juxtaposed nudity with Muslim dress. 'Don't they have warehouses in West London?' complained a fashion journalist in British *Elle* afterwards. Between space and light, between two cultures, between the cracks…it's easy to miss an interstitial space, especially because Chalayan's designs are so pure and abstract that they seem barely there at all.

In architecture the interstices are where the problems start. Fungi grow and damp seeps in the minute gaps between elements. But, as Marx wrote, 'in history, as in nature, decay is the laboratory of life.'[2] A strange and singular aesthetic ferments behind the run-down façades of the inner city, as well as in its tourist emblems that derive from bastardized forms of history. Hussein Chalayan's graduate show from Central Saint Martins featured fabrics which had been buried with iron filings to produce a veneer of rust. Shelley Fox's wrecked textiles have the patina of decay and age: wool is felted and scorched, laser-cut and bubbled. White, loom-state elastoplast is burnt with a blow-torch. Ripples and scars that appear are mishaps, resembling the scarred bodies suggested by the medical themes she has researched in the Wellcome Institute in London. Yet there is also a healing connotation in her use of muslin and wadding, and her signature felted wool is reminiscent of Joseph Beuys' use of felt and fat. Bandaging is used

1. Although Andrew Tucker's *The London Fashion Book* (Thames & Hudson, London, 1998), which showcases London designers, also pictorially maps seven fashion zones of the city. One, the East End, uncannily replicates many of Iain Sinclair's psychogeographic sites documented in: Iain Sinclair, *Lights Out for the Territory* (Granta Books, London, 1997). This book, aptly subtitled *9 Excursions in the Secret History of London*, captures the complexity of the city in fragmented and episodic forms. Patrick Keiller's film *London* (Argos Films & the British Film Institute, 1993) evokes the same London. Both derive many of their ideas from Baudelaire's idea of the flâneur and the Situationists' concept of *dérive*, or drift, in the city. Sinclair 's descriptions of surveillance in the city also tally strikingly with those of Vexed Generation.
2. Quoted in Georges Bataille, *Visions of Excess: Selected Writings, 1927–1939*, ed. and trans. Allan Stoekl (University of Minnesota Press, Minneapolis, 1985) p.32
3. Sigmund Freud, Standard Edition, Vol.IX, 1908, *Creative Writers and Day-Dreaming*. Also, Vol.XVIII, 1920, *Beyond the Pleasure Principle of a Young Child's Game of 'fort-da'*. (Hogarth Press, London, 1953)

not to wrap the body but draped on it in the metre-wide strips in which it is woven before being cut into 10 centimetre widths. Fox's aesthetic of ruination, with its emphasis on imperfection and the beauty of the flaw, mirrors the urban fabric of the old garment district in which she works, with its history of tailoring and sweated labour. The texture and fabric of the city mutates into the fragments of these clothes so they are almost site-specific.

Robert Cary-Williams cuts away at his garments, leaving only the armature of a dress: seams, cuffs, and trailing zips sketch the ghostly presence of an earlier garment. Flesh-coloured leather is soaked, moulded to the body, then baked, or shredded into ruched or plaited strands. The results are not inherently violent, only poetic and strange; even where slashed leather resembles scar tissue Cary-Williams makes it delicate and beautiful. His work is not about deconstruction so much as transfiguration. Apparent destruction turns out to be a novel form of enquiry. For Freud, adult creative activity is a continuation of childhood play which is, therefore, always creative, even when it appears destructive, because it is an attempt to interpret and understand the world, even to acquire a degree of mastery over it through 'describing' it.[3]

There is something of the intense curiosity of the child in Shelley Fox's explorations of materials, or Robert Cary-Williams' compulsive taking apart of objects, or in Boudicca's designs inspired by genetically mis-shaped clothing forms, producing beauty from aberration. Instead of an aesthetic of the ugly, Boudicca's shattered tailoring, with jacket parts grafted on to coats and dresses, simply redefines 'normality'. Boudicca's inspiration often comes from unlikely sources such as the news. Death, technology, chaos, genetic engineering, illness and sexuality are themes played out in and around the body.

Unspoken prose permeates Boudicca's designs: clothes from one collection came with a notebook for the wearer to record the adventures of the garment. In the installation *Immortality* the modernist rubric 'form follows function' is replaced by 'form follows emotion.'

The gigantic photo-column shows Julia Ain-Kruper, a muse and writer, whose intimate monologue, in the adjacent video, covers the suicide of a member of her family. Boudicca doesn't believe in dressing up to cheer yourself up but in exploring all your emotions, which is what the designers say their clothes do.

Biography patterns Jessica Ogden's clothes, too. Made from secondhand fabrics, they bear the trace of the past in their stains, darns or hand-sewn seams. Rather than reviving their unknown histories she gives them a new life. She says she doesn't get on with new clothes: where she uses new fabric, like the muslin in *A Dozen Dresses*, she tea-stains it, not to antique it but to imbue it with feeling. The graduated dresses might suggest the passage from childhood to adulthood, but the smallest dress could never have been worn by a baby. It was fitted to a doll, the largest to Ogden herself. The empty forms are ghostly, waiting to be filled, suggesting histories which are either yet to be written, or irretrievably lost. Intending to suggest a memory and create a space that has feeling, Ogden resists over-precise interpretation, preferring viewers to bring their own histories to bear on the installation.

Deborah Milner's influences are largely sculptural. She makes both experimental and wearable clothes; the techniques learnt from her cut and make experience contributes to the success of her more avant garde pieces, and vice versa. Her black Rigelene dress, inspired by a piece by the German artist Brigitte Meier-Denninghoff, is made of the plastic boning used in corsets. It has a corset inside but displays its innards on the outside. This kind of reversal typifies many of the designers discussed here, who peel away layers of meaning to bring an underlying structure to the surface.

Alexander McQueen works in Hoxton, whose disreputable history of theatre and music hall is replayed in the theatricalism of his runway presentations. All panache and effects, they mix the drama of Victorian popular entertainment with the pizzazz of the contemporary fashion spectacle. John Galliano, like Vivienne Westwood, explicitly

Left: the street outside product designer Tord Boontje's studio in South London. Boontje, who has collaborated with both Shelley Fox and Alexander McQueen, holds the deep conviction that urban spaces can offer designers useful materials others have discarded. Photograph: Tord Boontje

plunders history. An eclectic image-maker, his hybrid characters mutate from a fusion of early twentieth century figures: Kiki de Montparnasse rubs shoulders with the Marchesa Casati, Claudette Colbert with Sally Bowles. Galliano's aesthetic is luxurious, exotic and Parisian. Yet his endless pursuit of transformation originates in the London club scene of the early 1980s when clubbing was closely linked to dressing up in different personae. Galliano takes us back, not *in* time but *through* time, laying down parallel rhythms and tracks, mixing and sampling different historical fragments. Other designers manipulate biography or the urban fabric. For all their differences, the designers discussed here all share a magpie approach to politics, history, culture and materials, scavenging and mixing them in ways that echo the messy vitality of the city itself.

Fashion designers work in a world whose currency is the magazine front cover; the editorial spread; the styled photo shoot. Successful designers are under extraordinary pressure from hundreds of magazines all over the world, wanting photographs or clothing samples to fill their editorial pages. As a result, a network of support teams has grown up to serve the fashion industry, consisting of press and public relations people, publicity coordinators, editorial stylists and fashion photographers.

For most people, the media provide the only contact with experimental or couture fashion. These garments are either too expensive or unsuitable for mainstream retail distribution, and we are left to consume fantasy images of magazine photo shoots. The images featured in the next 14 pages are the result of a fashion shoot commissioned for *Lost and Found* in collaboration with the fashion magazine *Tank*. Photographers Barnaby and Scott, together with stylist Charty Durrant, created their scenario at an English country house. The photographs also appear in the June 1999 issue of *Tank*.

Photographs on pages 98–111:
Barnaby + Scott
Styling: Charty Durrant
Hair: Mandy Lyons
Make-up: Debbie Stone
Photographic assistant: Ian Dickens
Dancers: Ruth Lloyd and Litza Bixlier
With special thanks to: Audrey Hayley

98–9: Black leather 'cut me out' top and black 'coffin' skirt with tail by Boudicca
100: Black cashmere polo neck and wool bondage trousers by Fake London
101: Fibre glass moulded chair piece by Hussein Chalayan
102: Prince of Wales check two piece suit sprayed multi colour by Owen Gaster
103: Black Rigelene floor length dress by Deborah Milner
104–5: White scorched full circle skirt, cardigan and tank top by Shelley Fox

106: Black ballistic parka '99 by Vexed Generation
107: Beige leather halter top and wooden lattice fan skirt by Alexander McQueen
108–9: Grey stripe crepe 'pulling' dress by Vivienne Westwood
110: Flesh coloured multi zip leather boiler suit by Robert Cary Williams
111: Cream calico dress (part of '12 dresses') by Jessica Ogden

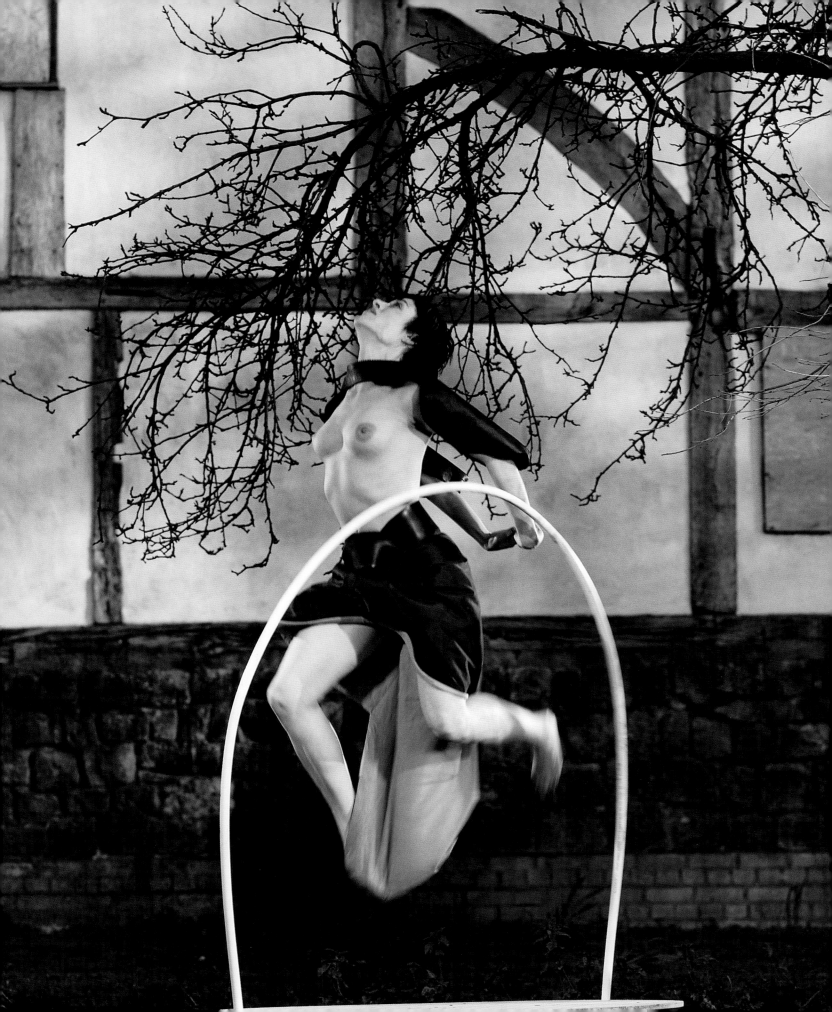

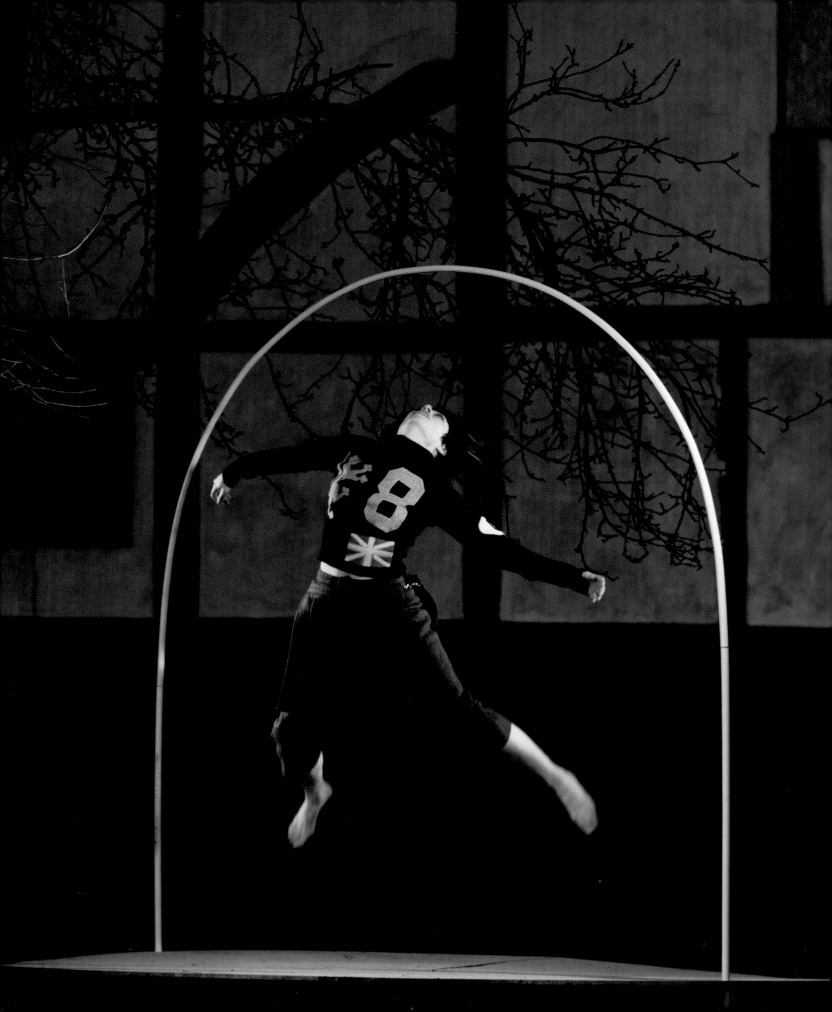

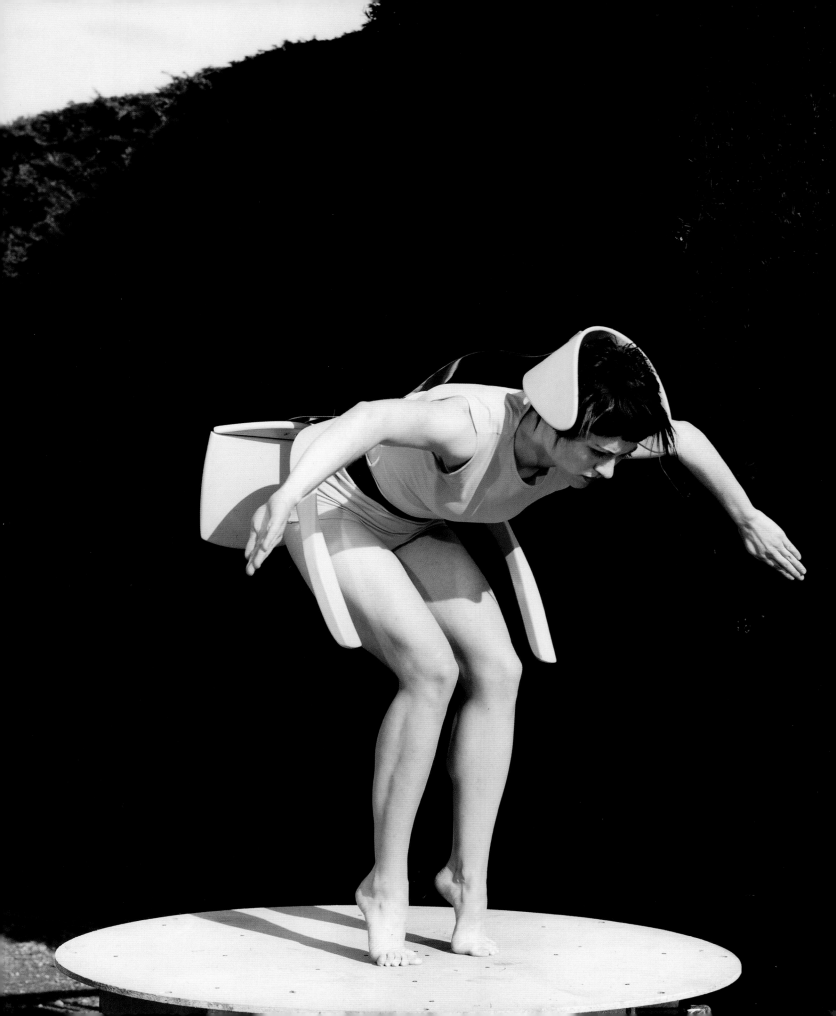

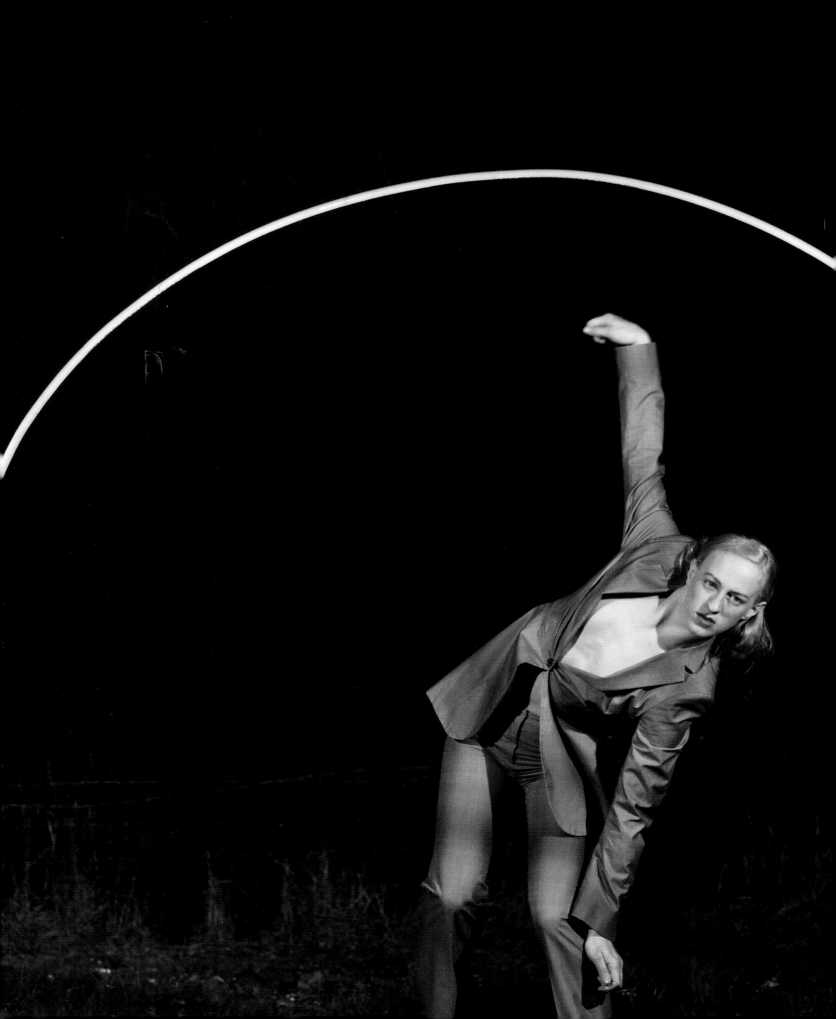

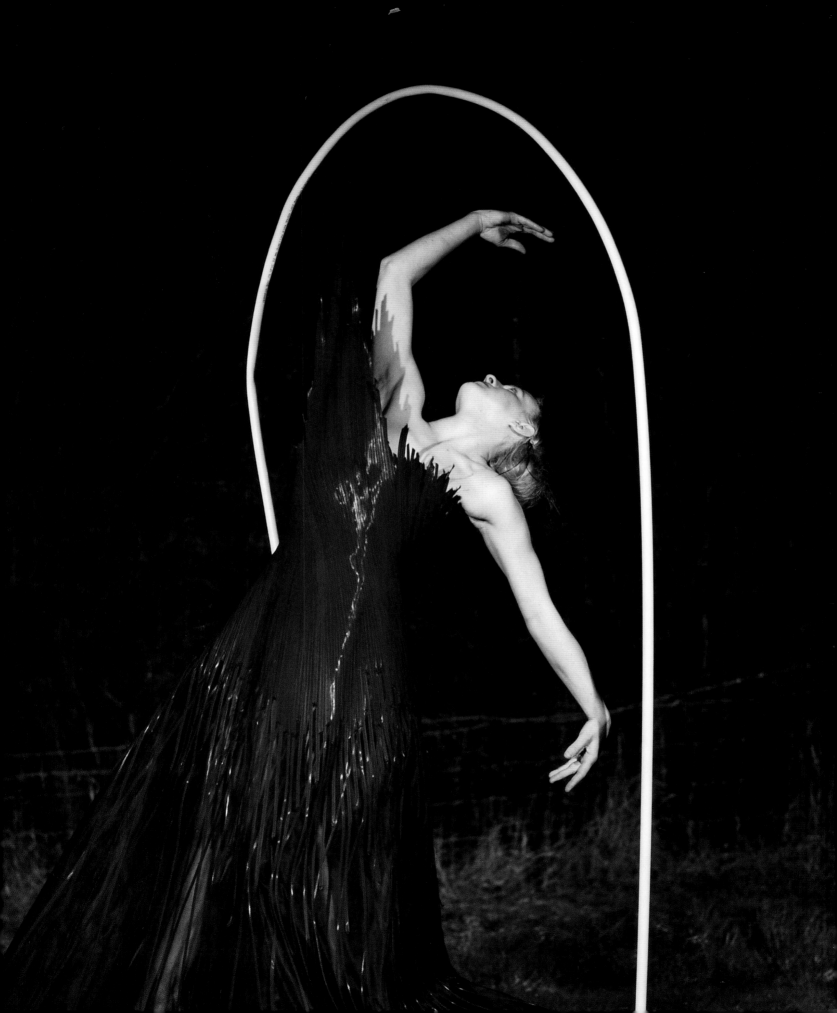

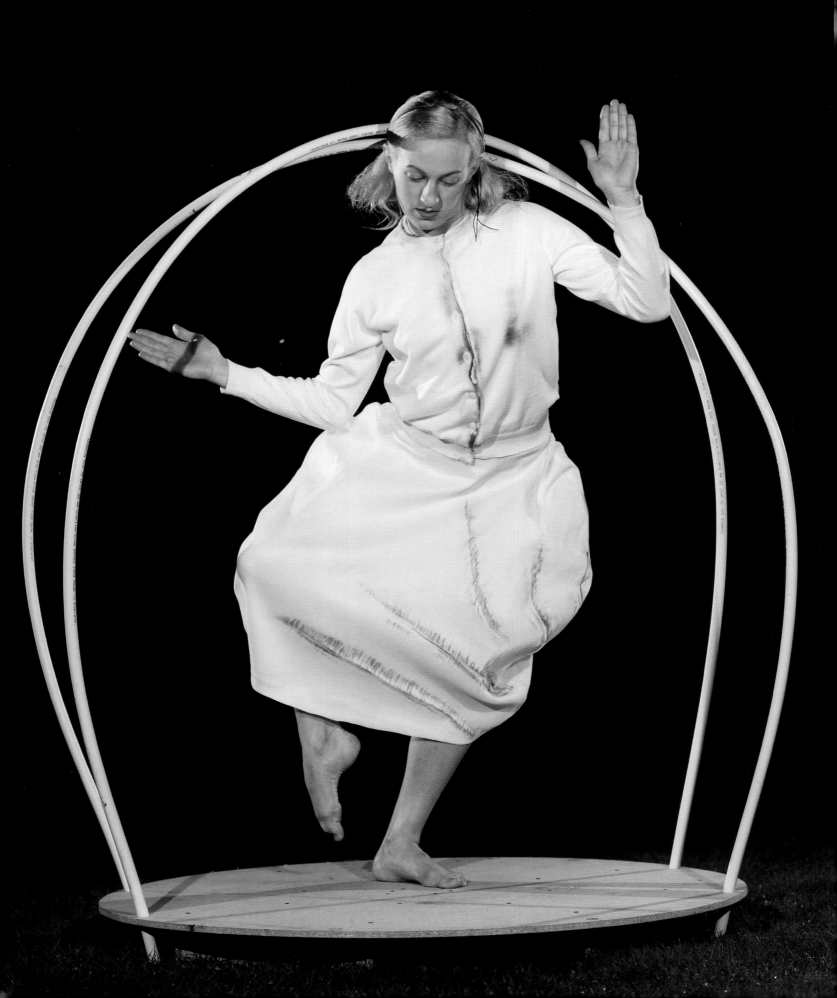

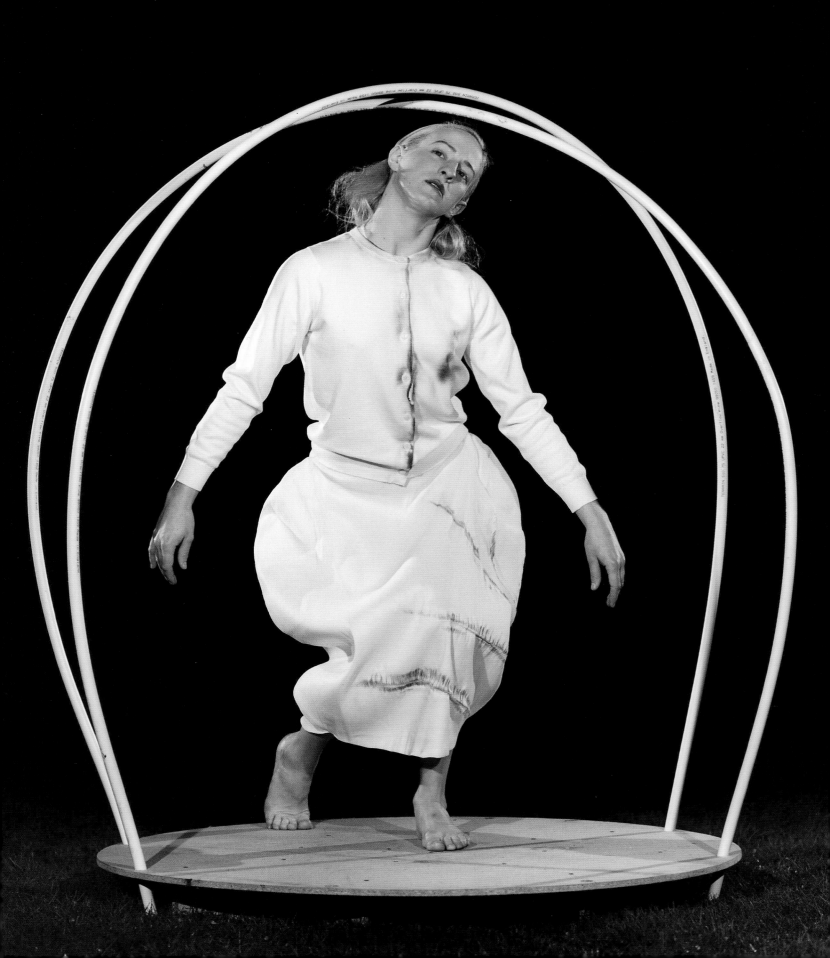

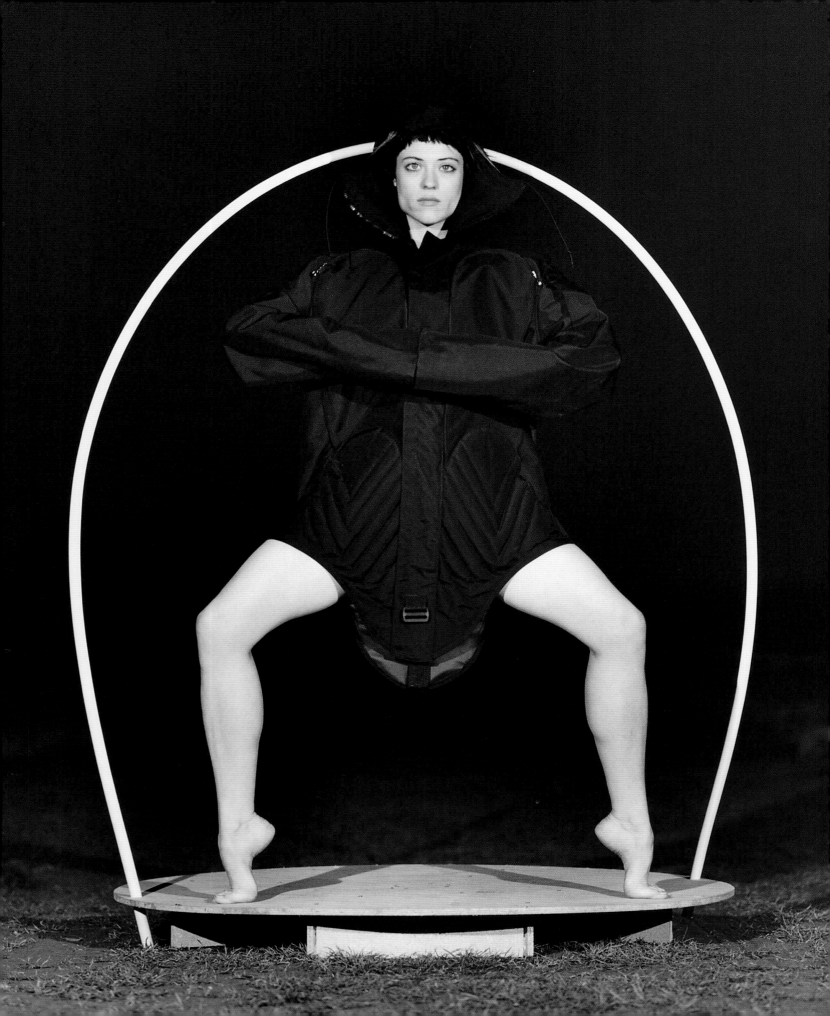

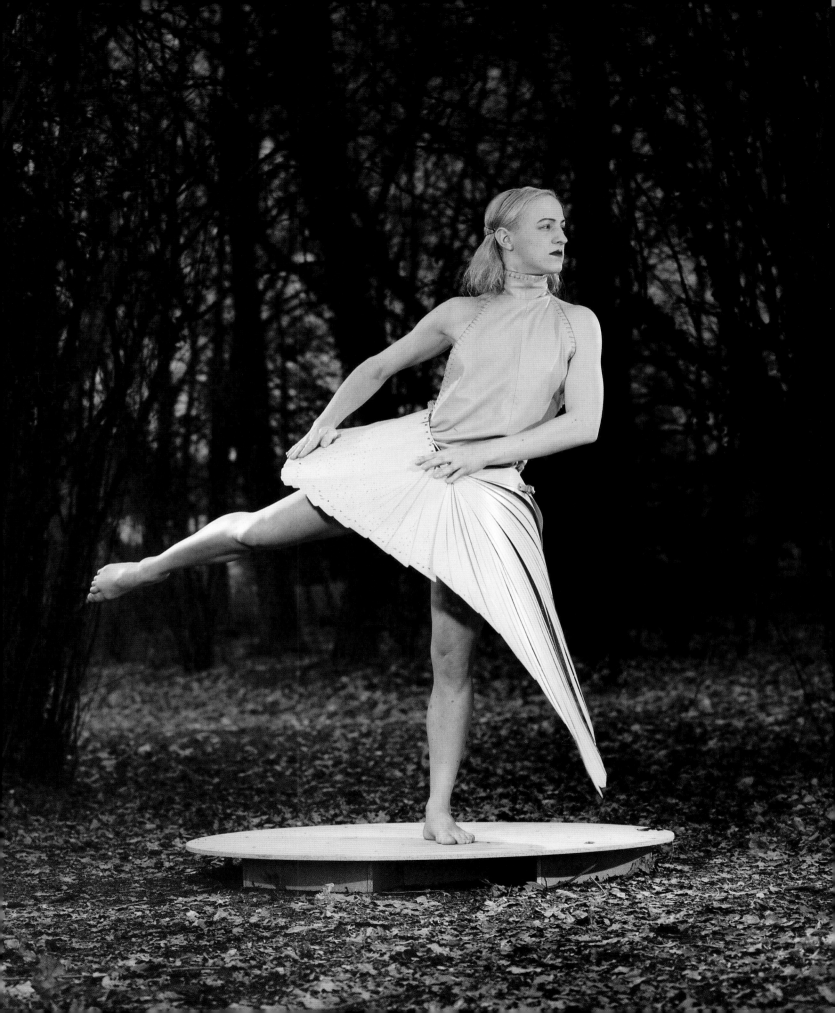

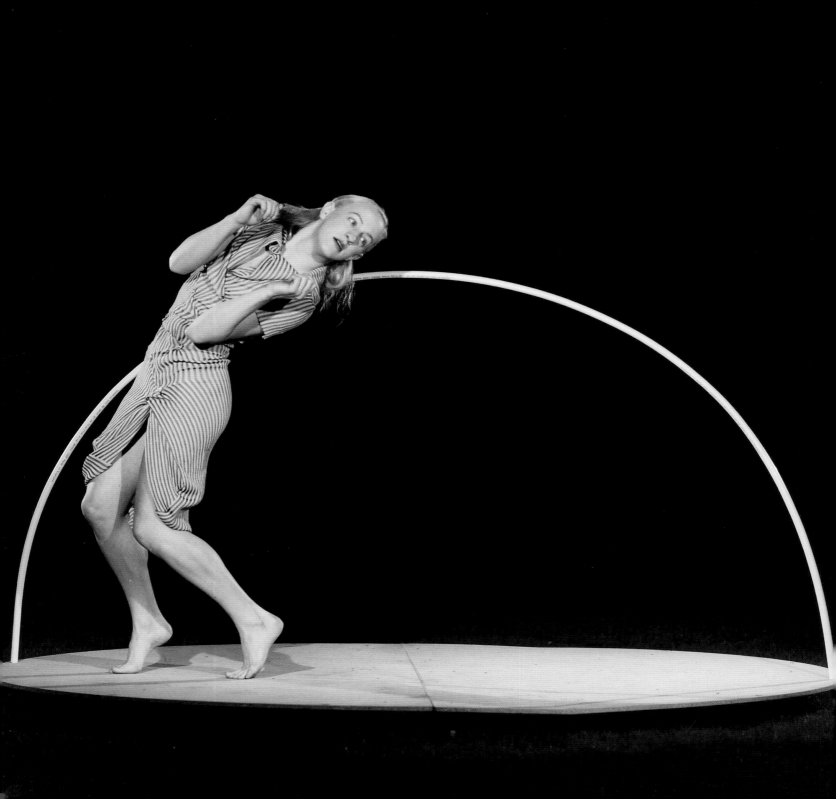

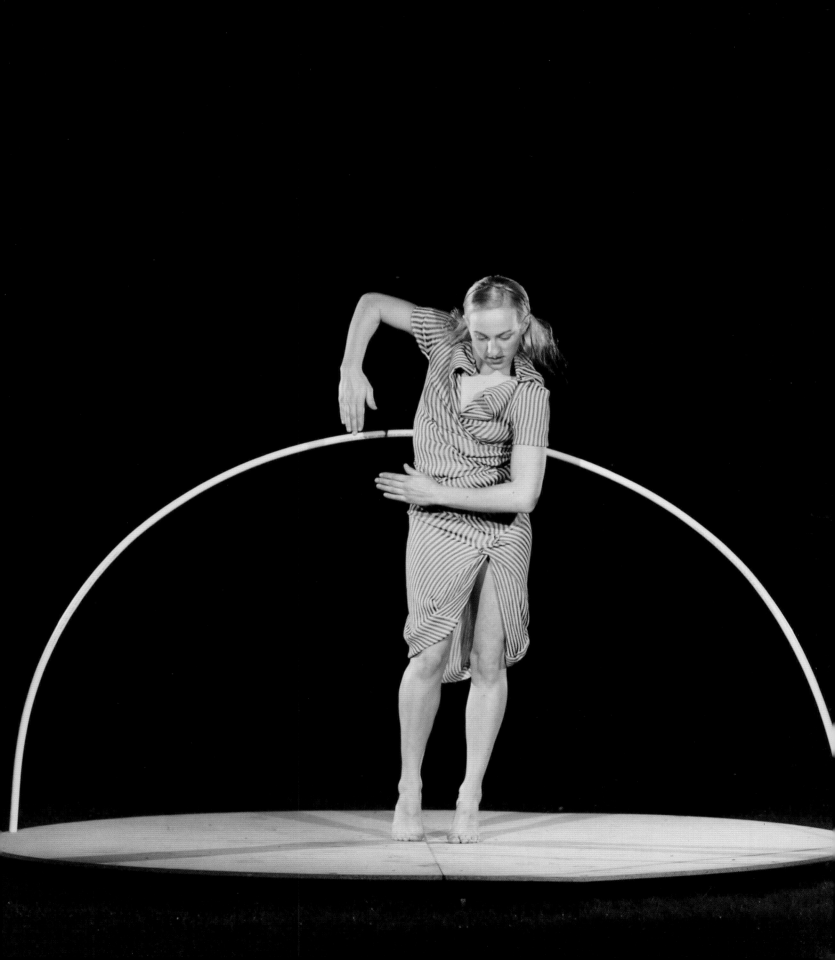

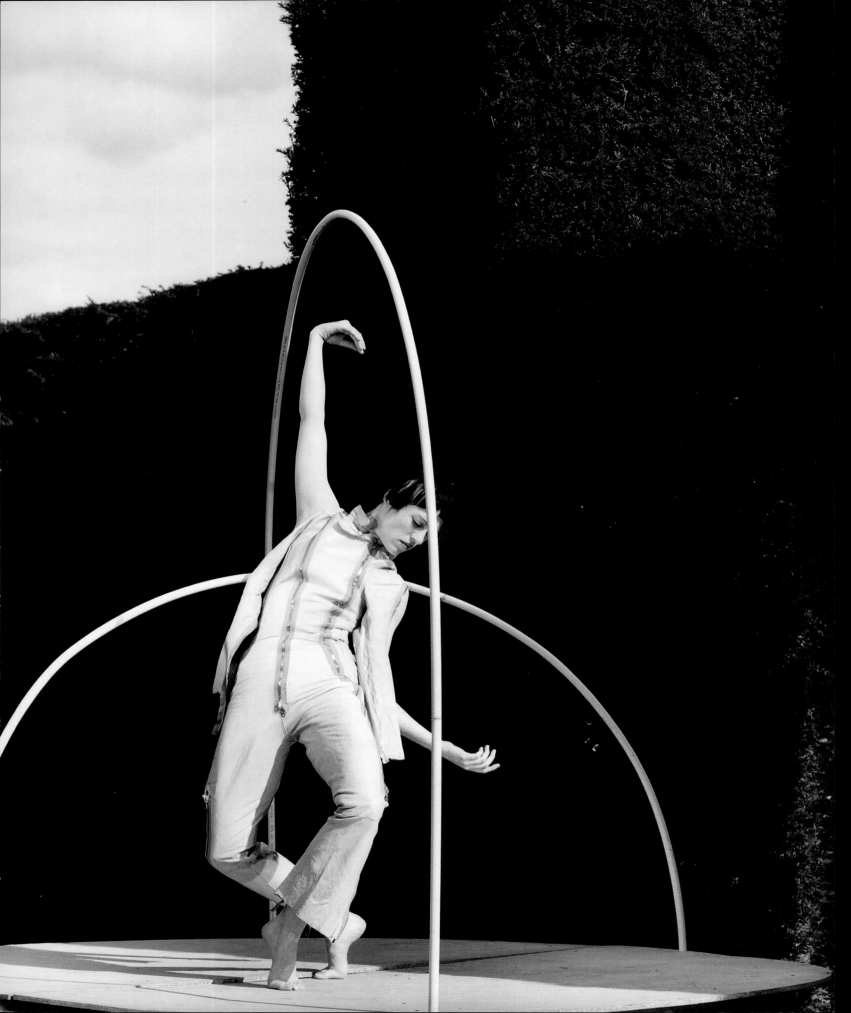

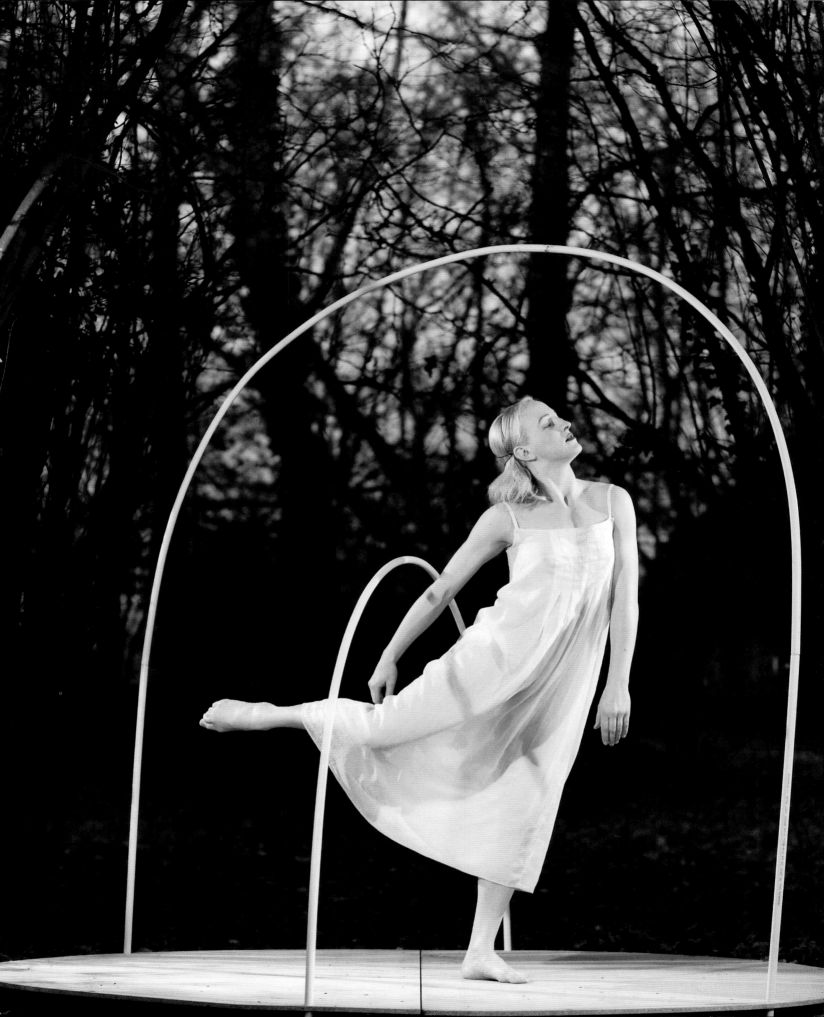

Fake London's best-known garment, this sweater features a Union Jack made from pieces of cashmere sewn together. Spring/Summer 1997/98 collection. Photograph by Jonathan DeVilliers

Fake London

Desirée Mejer arrived in London from Spain in 1992 and with no formal training, set up her Fake London label in 1995. The first collection was launched during the Autumn/Winter 1997 season.

Fake London's best-known work consists of cashmere pieces of different colours which have been sewn together to create conventionally-shaped jumpers which carry iconoclastic motifs. In one famous series of sweaters, the shape of the Union Jack is constructed from these cashmere fragments [above], but rarely in the traditional red, white and blue of the national flag. Mejer has completed over 2,000 variations on the design including, for example, the green, orange and red of the Rastafarian flag. As a result, the nationalist associations of the British flag are subverted.

Developing the iconoclastic theme, Fake's jumper designs have also included a cut-out of the Queen's head in the distinctive silhouetted style of a coin or a British postage stamp, but with a set of fake pearls sewn on to the neck. As well as mocking the cashmere normally associated with British upper class values, the gently anarchic abuse of a symbol of the monarchy has clear echoes of the punk style of the late 1970s. It is a style which has gained much attention from the music business: "We get lots of requests from record companies and stylists wanting to use Fake to create an image for new bands, so we have to be selective. Our biggest fan, and someone we have enjoyed working with, is Keith Flint from The Prodigy," says Mejer. Less well-known, but equally irreverent are the flippant references to South London council estate 'wide boys' suggested by sweaters featuring cut-out images of a pit bull terrier.

Fake London's most recent collection draws on the small print attached to British advertising messages, such as a phrase recognisable instantly to British consumers, "Your home is at risk if you do not keep up repayments on your loan/mortgage." It is the small print in magazine advertising, or is spoken quickly at the end of TV and radio advertising in apparently reluctant compliance with advertising regulations. Printed in an old-English style gothic typeface on sweaters using gold-leaf foil block printing, the familiar phrase is shortened simply to "Your home is at risk". Suddenly, a phrase repeated so often as to become almost meaningless is transformed into a blunt but ironised warning about the risks of over-consumption.

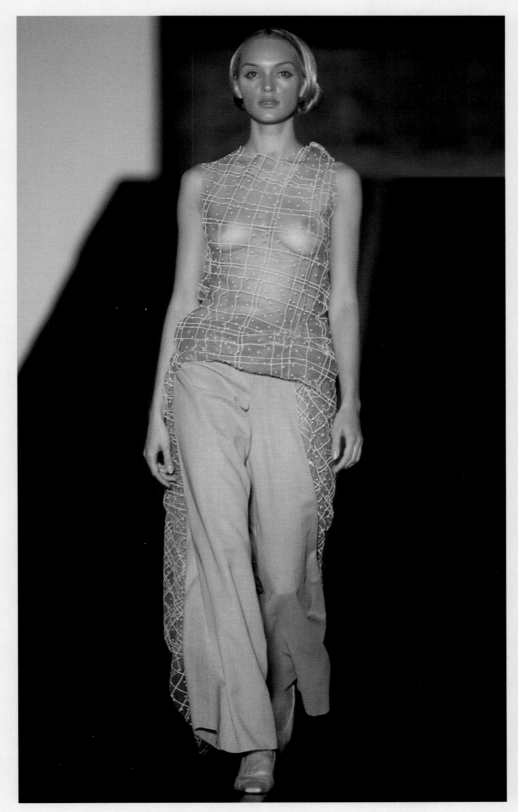

Turquoise tulle and cotton wide-legged pant from the Spring/Summer 1999 collection, 'The Long Walk Home'. Photograph by Bruno Rinaldi

Having left school at the age of 16 to enrol in a Fashion BTec at Hastings Technical College, Owen Gaster then went on to complete a BA at Epsom College of Art and Design, graduating in 1992. Gaster first came to the attention of the media with his degree show, his twisted, structural tailoring winning him editorial coverage in *iD*, *Vogue* and *Interview*. "There was a random element and I achieved results you could never get from working with a pattern," he told Caroline Roux in *Blueprint* magazine in 1996.

Gaster combines his talent as a tailor with a reinterpretation of British city sub-cultures such as the urban black phenomenon of ragga style. His interests are rooted in the contemporary world and his work amounts to a fond celebration of aspects of material culture, such as the working class lad's love of souped-up cars with go-faster stripes, and the urban girl's desire to assert her aspirations by dressing up for a night out. His work represents a selective anthropology of suburban London, drawing on the same wide-ranging references – from the "casual" clothing popular on English football terraces in the early-1980s to sprawling motorway junctions built in the 1960s – that have played a fundamental part in a popular reformulation of the notion of 'working class' over the past 20 years. Once a term which might suggest poverty and a lower class status, 'working class' is now more commonly used in a celebratory manner to indicate a sense of belonging and identity which is much deeper than simple political opposition to bourgeois attitudes.

Drawing inspiration from the street and its subcultures is not unique to Owen Gaster, but its combination with sharp tailoring and sophisticated pattern-cutting has a trademark style which is unmistakeable. "It's not actually necessary to be that tricky," he told *Blueprint*. "You don't really have to make things this complicated... But I do."

To add to the complexity, Gaster experiments with new materials. His ragga-inspired Spring/Summer 1998 collection used spangly blue lurex and a traditional Dior check dyed bubble gum pink. Yet despite all this experiment and formal sophistication, there is nevertheless the overriding sense that Gaster's clothes would be exactly the kind of special garment that the people who inspired them would choose for a glitzy night out.

Vexed Generation

Woollen 'Shark Coat',
1998. Photograph by
Johnny Thompson

Adam Thorpe and Joe Hunter are Vexed. Neither had a formal fashion training; Thorpe studied Microbiology at Kingston University and Hunter graduated as a graphic designer at Middlesex in 1990, but together they have created a label which epitomises the attitude of a growing number of fashion designers who eschew the culture of the catwalk.

Vexed Generation have powerful political convictions which have led them to design solutions to social problems as well as fashionable clothes. Bags that are easier to carry and harder to snatch; trousers made in light weight, hightech, hardwearing materials with soft, speedy Velcro fastenings replacing old-fashioned zips, buttons and poppers. All of their clothes are derived from their conviction that urban conditions place us under constant danger. Air pollution, constant surveillance, over-zealous riot police and the risk of attack form a threat to our civil liberties. The garments parody the situation, and then offer some protection too.

The Vexed parka, the duo's most notorious garment, is made from "Ministry of Defence-specification nylon; the same stuff they use in flak jackets," says Thorpe. The parka's knife-repellent, fire-resistant fabric is padded around the spine and kidney areas, and has a between-the-legs fastening to protect the groin.

The more recent woollen Shark Coat [left] was developed in response to the contemporary political landscape in Britain. The abundance of surveillance cameras in city streets – characterised at its most extreme by a new multi-million pound digital facial recognition system installed by the London Borough of

Newham – provided an impetus for the design of the Shark Coat. Like other Vexed garments it features a collar which can transform into a hood, offering the wearer the option of anonymity. "The higher the levels of surveillance, the higher the collarlines of the populace!" says Thorpe. Moreover, the 1998 Crime and Disorder Act effectively renders it illegal to cover one's face in a political demonstration by granting the police powers to confiscate face coverings. This could have the ironic effect of making the garments an illegal political protest in their own right.

As a designed response to the current socio-political climate in urban Britain, Vexed Generation's clothing positions itself far away from the concerns of the fashion establishment. The garments are, nevertheless, clearly articulated and architecturally structured, with a shrewd sense of style which has made some of the cheaper designs enormously popular in London. As well as being politically aware, Vexed Generation claim modestly that their company aims to be "commercially viable".

Below left: dress made from polyester and ramie, from the Spring/Summer 1999 'Geotropics' collection.
Below right: 'Chair Dress', made from chrome and moulded plastic, also from 'Geotropics'. Photographs by Chris Moore

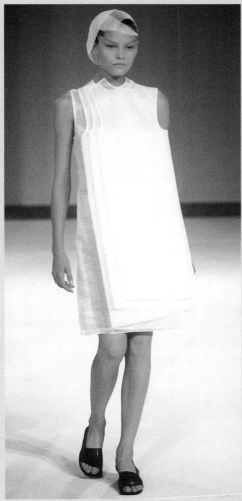
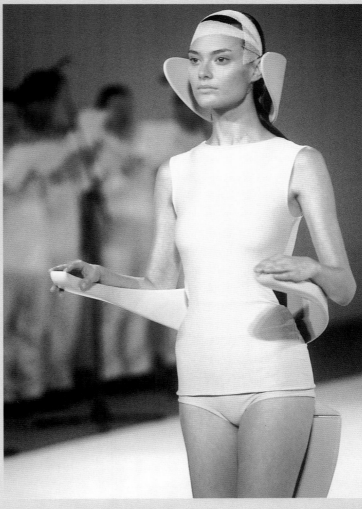

Hussein Chalayan

In an industry dominated by the thrill of the new and the buzz of the latest catwalk collection, one designer's work stands out for its ability to transcend the commercial dominance of fashion's seasons. Hussein Chalayan, born in Cyprus, graduated from St Martins as recently as 1993 but already he is recognised as one of the brightest talents in British fashion design.

Chalayan first became known when his final collection for St Martins, consisting of clothing covered in iron filings that had been buried in a garden for six weeks, was exhibited at a leading London fashion store, Browns. The collection was built around the tale of a fictional female scientist imagined by Chalayan, and demonstrated a fascination with scientific and philosophical theories. The garments were made using complex mathematical cutting and featured formal prints

resembling minimal music scores. "I look at the role of the body in different cultural contexts, such as architecture, science or nature, and see how these approaches can be applied to clothing," he told Andrew Tucker in *The London Fashion Book* in 1998.

Hussein Chalayan's designs are austere, rather than pretty, and delivered on the catwalk with a resolute seriousness. For several seasons he has employed bizarre contemporary choral music as well as collaborating on a regular basis with product designer Michael Anastassiades (page 66) on the construction of sombre white stage sets which form a backdrop to the catwalk shows. Anthropomorphic jewellery by Naomi Filmer and styling by Jane How are also used to add to the carefully-orchestrated delivery.

A chair/dress constructed from chrome and moulded plastic [above] was the climax of the Spring/Summer 1999 show, while Chalayan's creations for Autumn/Winter 1999 draw on the language of car seats. Here, models wore collars formed from foam-padded fibre-glass which were covered with leather in a style reminiscent of head rests.

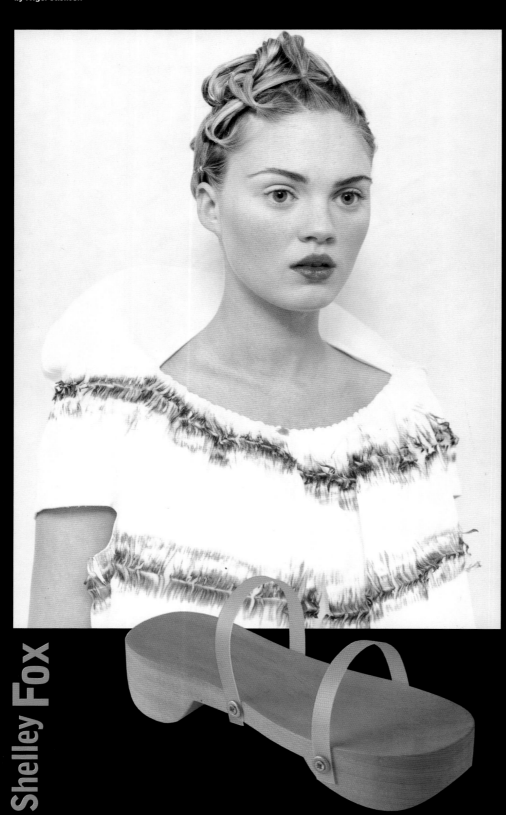

Shelley Fox

Shelley Fox grew up in the small Yorkshire town of Scunthorpe, and trained in Textiles as well as Fashion, completing her MA at St Martins in 1996. She launched her business from a small studio in East London's Brick Lane in 1997, and less than two years later, in February 1999, Fox was awarded the prestigious Jerwood Fashion Prize, with new studio facilities and commercial backing to help fulfil orders – as well as a large sum of cash – forming a prize worth well over £100,000.

Fox treats her studio like a laboratory. Its walls are covered with Victorian photographic images and with the negative imprints of a screen-printing process which involved pressing crumpled garments into a pigment so as to highlight the cracks and folds which form part of the personality of most natural fabrics. She is, nevertheless, just as likely to toast fabric or spray it with car paint as to screen print it.

Fox seems to see clothes as something that wrap the body, rather than something we wear, and as representative of society's restrictions and rules. Instead of representing our individuality, they can just as easily show our oppression. She bases much of the structure and content of her work on traditional ways in which bandages are applied to the body, and is fascinated with documentary photographs of nineteenth-century bandaging techniques which she discovered in the Wellcome Institute Library. While much fashion is about denying the reality of the body, Fox takes inspiration from its flaws. "I deal with an overall idea of humanity," she says.

'Apron Dress' made from
fishing net with leather
trim, part of the
Spring/Summer 1999
collection. Photograph
by Chris Moore

Robert Cary-Williams

Robert Cary-Williams was, prior to his training as a fashion designer, a soldier in the British army. However, although the army has clearly played a profound role in shaping his fashion design ideas, Cary-Williams' military career ended in the early 1990s and for much of this decade he has been studying at St Martins, completing his BA in 1994 and an MA in 1998.

Cary-Williams' background as a member of the army has clearly influenced his choice of garments, but his use of utilitarian army surplus clothing as a starting point refers above all to the fact that garments are a necessity as much as a form of self-expression. He is interested in the conceptual possibilities in fashion as a medium for creative thought, and the influence of Belgian fashion designer Martin Margiela is present in his work alongside the legacy of the Northern Ireland conflict and the rhetoric of the army camp. Increasingly, the results of Cary-Williams' work are not intended to be mass-produced or made commercially available, erring instead on the side of experiment and personal exploration. According to Caroline Evans, a tutor at St Martins (see pp. 94–96), "Robert was always known to his fellow students as 'the one over in the corner toasting leather'."

Already widely fêted in British fashion circles, Robert Cary-Williams is nonetheless a relative newcomer to the scene, with his output by early 1999 extending to just two collections. He has established an important relationship with the stylist Katy Grand, who as well as collaborating on both his collections is also fashion director of the London-based style magazine *Dazed + Confused*. Grand has been responsible for a series of controversial and high-profile fashion stories in the magazine, which has been firmly established as a key barometer of trends in British fashion throughout the mid-1990s.

Where much of fashion is an anxious exercise in perfection, Robert Cary-Williams is as likely to put energy into destruction. He makes a garment then scores it into feathery pieces with sharp scissors, creating something that relies entirely on the basis of its construction (the seams, collar and cuffs) to be wearable. The work questions our obsession with how things look, and how we normally find comfort in the application of clothing as a shield between ourselves and the world.

Photographs taken by
Boudicca of in-house
model Rebeka Bardow
wearing a calico 'toile
sketch' garment, 1998

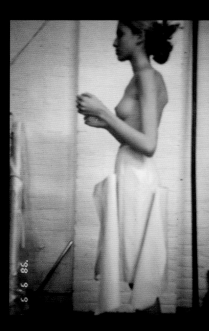

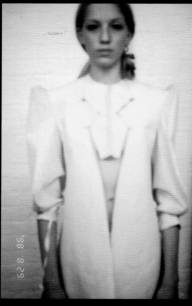

Boudicca

"Who are the people that do not live as part of accepted thought? Who are the renegade creators? They are Boudicca." So runs the text in Boudicca's promotional literature, with a politicised style which characterises their output. Formed in 1996, Boudicca is the label of fashion designers Brian Kirkby and Zowie Broach. Broach graduated from Middlesex Polytechnic in 1991, while Kirkby completed his MA at the Royal College of Art in 1994. Kirkby had previously produced collections under the name of Brian of Britain (a play on the title of the classic British radio quiz 'Brain of Britain'), and had exhibited in the influential design exhibition 'Jam' at London's Barbican Centre in 1996.

The partnership's choice of name hints at their iconoclastic stance: almost two thousand years ago the original Boudicca was Queen of the Celtic Iceni tribe from Norfolk in eastern England. In AD61 she led a revolt against the occupying Romans and her troops burned and destroyed major towns of England including London. Boudicca eventually poisoned herself in order to avoid being taken prisoner.

Boudicca – the fashion designers – make clothes which, like their namesake, question and often reject received notions of personal and national identity and seem to encourage a twist in the concept of 'Britishness'. "We're not really interested in this season's colour or look; our approach is more concerned with why people wear what they do, what it says about them and how this can be used to explore the way you are feeling," says Kirkby. "It's investigative rather than simply decorative." In one recent collection the clothes came with a notebook in which the wearer could detail how and why she wears them.

In their collection 'Immortality', Boudicca explore their thesis that clothes cannot be neutral but are a major statement of identity. First exhibited in Copenhagen in late 1998, it features Boudicca's muse, a young woman whose sense of self is explored in a contextual video and her description of the impact of a close friend's suicide. The idea is derived from writer Milan Kundera's text: "immortality is when people remember you who don't know you."

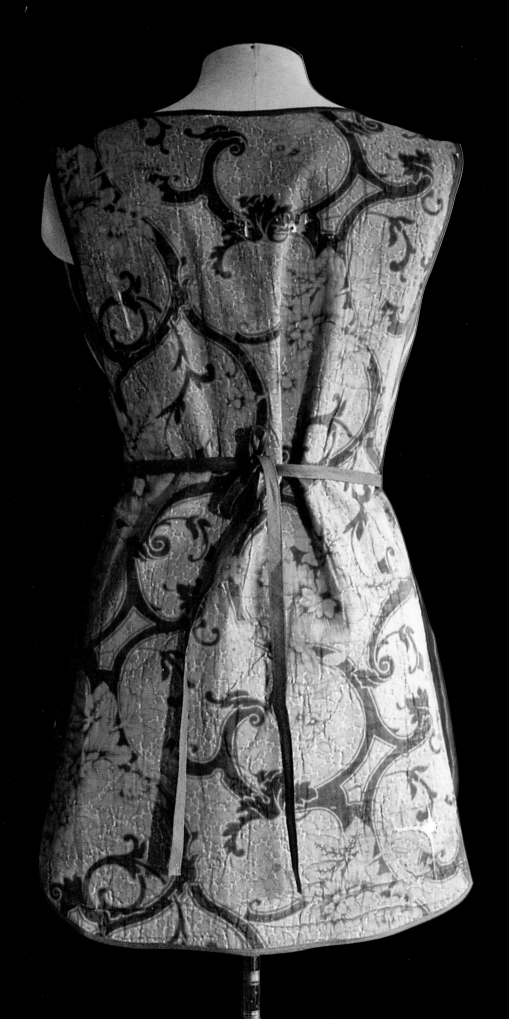

Medium overtie pinnie on a brown and orange antique print. Spring/Summer 99. Photograph by Stephen Mail

Jessica Ogden

Jessica Ogden studied fine art at the Byam Shaw School of Art and became involved with clothing in 1993 through the recycling project coordinated by the British famine relief organisation Oxfam. Ogden's college work consisted of installations and sculpture but, "drifting round charity shops and markets all year long, picking up piles of old blankets" led to an increasing interest in clothing.

Partly as a result of her education, Ogden's work today is closer to sculpture than conventional ideas of fashion. She works with both new and used textiles to create clothing of extraordinary integrity and individualism. She finds the found textiles she uses beautiful in themselves – for their colours, their textures, and even their states of decay – and regards her appropriation of them as simply the next stage in their lives rather than an end in itself. Many of the old textiles bear vestiges of old sewing skills such as fine hand-stitching and quilting, which Ogden then weaves into her own designs.

Like Boudicca and Robert Cary-Williams, Jessica Ogden does not conform to the rhythms of the fashion mainstream; she values the creative exploration of clothing and its identity more highly than the production and marketing issues which dominate commercial fashion. It is an approach which can lead her to be wilfully uncommercial: "I sometimes get this strange feeling about the quantity of a particular garment I should make," says Ogden, "so I tend to get into the sort of situation where, if someone wanted to order three of something, I might find myself saying 'No, it's important that I make two. You can only have two.'"

Ogden's sensitivity with materials is illustrated by '12 dresses' which consists of twelve tea-stained muslin garments, identical in form but ranging in dimensions from doll-size to the size of an average woman (this largest garment was modelled on Ogden herself). The piece was commissioned by the cutting edge Soho fashion outlet The Pineal Eye, which has supported work that other more mainstream retailers would have rejected.

"The 12 dresses were initially intended to be shown in a long line, separately," says Ogden, "but I also like the idea of it being shown like a Russian doll, so that when you see the light through it you get an amazing outline of all the dresses inside each other."

Deborah Milner

Deborah Milner completed her degree
in fashion design at Central St Martin's
in 1987 and graduated from the Royal
College of Art with an MA in 1990. Having
gained experience working with companies
such as Jaeger and Austin Reed, she set up
her own couture studio a year later.

Milner's work is resolutely sculptural.
Making references both to natural
sculptural forms and to the tough steel
constructions more familiar in modern art
practice, Deborah Milner's garments make
visible the structural qualities of clothing
and fabrics which we might otherwise
take for granted. "I admire the effortless
beauty you find in nature, where you don't
see the construction take place," she says,
"like ice being formed on a window."

The black dress [right] made in 1998
from the Rigelene plastic normally hidden
in corsets, is the quintessential Milner
composition. Sculptural in form, the
Rigelene dress juxtaposes this quality
with the traditional elegance of couture,
and it is in this superimposition of
ideologies that the power of Milner's work
lies. Other couture pieces made for London
Fashion Week in February 1998, including
a lace dress constructed from old plastic
bags and a constructivist piece made
from zstainless steel, were exhibited at
the Hayward Gallery in 1998 as part of
its 'Addressing the Century' exhibition.

Although her work until recently has
been restricted to the realms of couture,
Milner does not feel any association with
other couture designers such as John
Galliano or Vivienne Westwood. "There
is absolutely no historical reference in my
work," she says. "To me the best sculpture
is that which is new; extraordinary but
functional."

Milner's aim is to make her
striking designs wearable. As well as
demonstrating exquisite tailoring skills
in garments for high-profile clients such
as Helena Bonham-Carter (who wore a
Milner dress for the Oscars in 1998) and
with a collection of outfits to accompany
the catwalk show of milliner Philip Treacy
in 1997, Milner also launched her first
Ready to Wear collection at the beginning
of 1999.

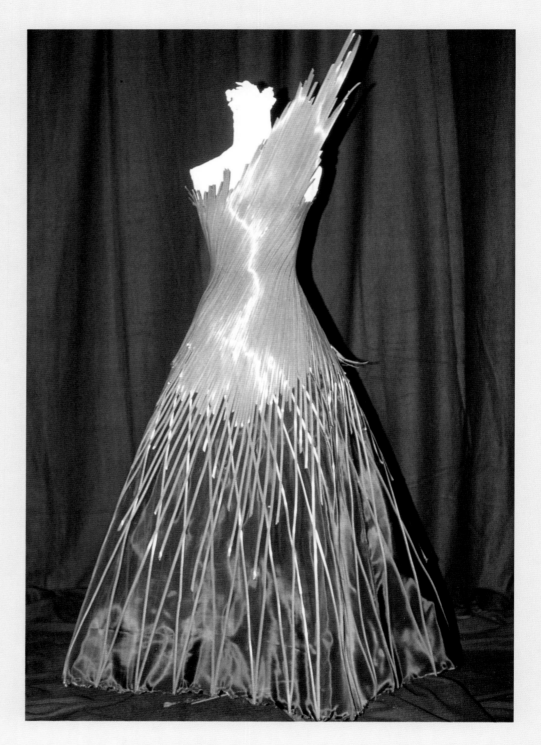

Grey leather top with etched metal skirt, from 'The Overlook' collection. Autumn/Winter 1999. Photograph by Peter Macdiarmid

If Alexander McQueen has a reputation as the wild boy of fashion, it is entirely deliberate. A sense of showmanship at least as sharp as his talent as a designer has helped catapult him to fame and a career at the heart of the fashion establishment. Born and raised in the East End of London, at the age of 16 McQueen started work as an apprentice at Savile Row tailors Anderson & Shepphard. Following a period of work in Japan for Koji Tatsuno and then Milan for Romeo Gigli, he returned to London and completed an MA at St Martins in 1992. Echoing the experience of John Galliano eight years earlier, McQueen's graduation collection was greeted by rave reviews and was immediately bought by the fashion impresario Isabella Blow.

In 1997 he became the youngest designer ever to win the Designer of the Year prize, and in the same year, again following in the footsteps of Galliano (although in an appointment which shocked the fashion world much more than Galliano's two years earlier), McQueen became head designer at the Parisian haute couture house Givenchy.

For a 1997 London show at the end of 1997 (described by fashion writer Andrew Tucker as "one of the most dramatic fashion shows ever staged"), McQueen drenched his models in rain which fell from high above the catwalk. As a result of sponsorship considerations, the title of the show was changed at the last minute from 'The Golden Shower' to 'Untitled', but the designer's iconoclastic reference to unusual sexual practices did not escape fashion insiders.

Such shock tactics are not the only reason for McQueen's success, however, and his memorable contribution to the profession is more likely to be the quality of the designs than the production gimmicks of his shows. An accomplished mix of street references and skilful tailoring, the garments betray a sophisticated understanding of the dual nature of clothing both as functional object and as signifier. McQueen plays with gender stereotypes, either enhancing them to extremes for women or transgressing them for men; he also plays up the absurdities and drama associated with the world of fashion in a manner more cynical and less historicist than John Galliano. Whatever the symbolism, the resulting clothes are characterised by exquisite craftsmanship.

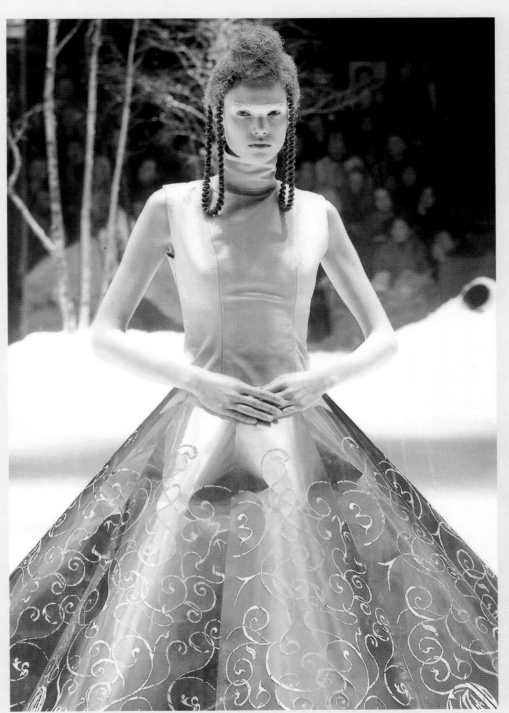

Alexander McQueen

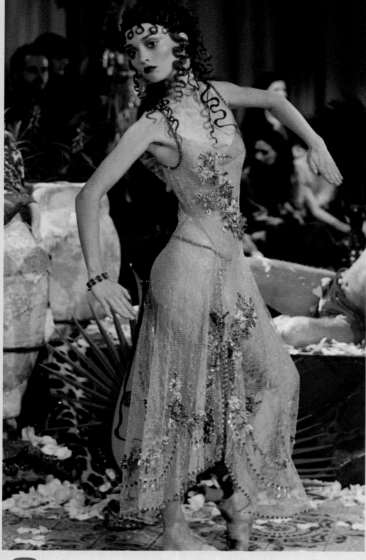

John Galliano

John Galliano is one of the most successful fashion designers Britain has ever produced. Born in Gibraltar to a Spanish mother and Gibraltarian father, Galliano moved to Britain at the age of six, in 1966. As early as 1984, when he graduated from St Martins in London with a First Class Honours degree, Galliano's exceptional talent was already being recognised by buyers and the fashion press alike and the London fashion store Browns snapped up the collection for display in its window.

Galliano's love of costume and history is always evident in his highly theatrical installations, which can involve staging and fantasy worthy of a West End musical. His graduation collection, 'Les Incroyables', was inspired by the French Revolution, while his Spring/Summer 1994 collection traced the escape to Scotland of a Russian princess in the 1930s, managing to mix high-society crinolines with reworkings of the traditional Scottish kilt in the same défilé.

Although he produced a number of memorable catwalk collections over the following years, the astonishing scale of Galliano's success was not to become evident until the end of the 1980s. In 1988 he won the prestigious Designer of the Year award with a collection inspired by Blanche Dubois, a character from the Tennessee Williams play 'A Streetcar named Desire'. It was the beginning of a sequence of honours which no other designer has matched. Galliano won Designer of the Year again in 1994, and for an unprecedented third time in 1995. By the time he was awarded it for the fourth time in 1997, Galliano had become possibly the best-known fashion designer in the world.

In July 1995, he was appointed head designer for the Parisian couture house Givenchy. It was a mark of Galliano's high reputation that this most traditional of fashion houses was prepared to place its trust in such a young British designer, and moreover the arrangement was a marketing hit, generating enormous publicity. Two years later, Galliano was promoted to head up the even more prestigious Christian Dior line.

"I imagine that within the industry I'm seen as someone who helped bring about a return to glamour, elegance, construction and technique," Galliano told the *London Fashion Book*, and his collections have consistently underlined the point. In 1997 Galliano's catwalk show recreated the rooms of a belle epoque apartment; in 1998 a collection took the form of one of the Marquesa Cassati's high-society parties of the 1920s; and in the same year the Wiener Werkstätte and the decadent life of Sonia Delaunay became the themes of the Autumn/Winter collection.

Although much of Galliano's design since 1995 has mixed strong narrative threads with traditional Parisian chic, his approach can be traced to growing up in Britain and in particular his experiences of the London club scene in the early 1980s. It was a period dominated by the post-punk New Romantic movement which idolised decadence and dandyism, while also revelling in wild cross-dressing and indulgently transgressive behaviour.

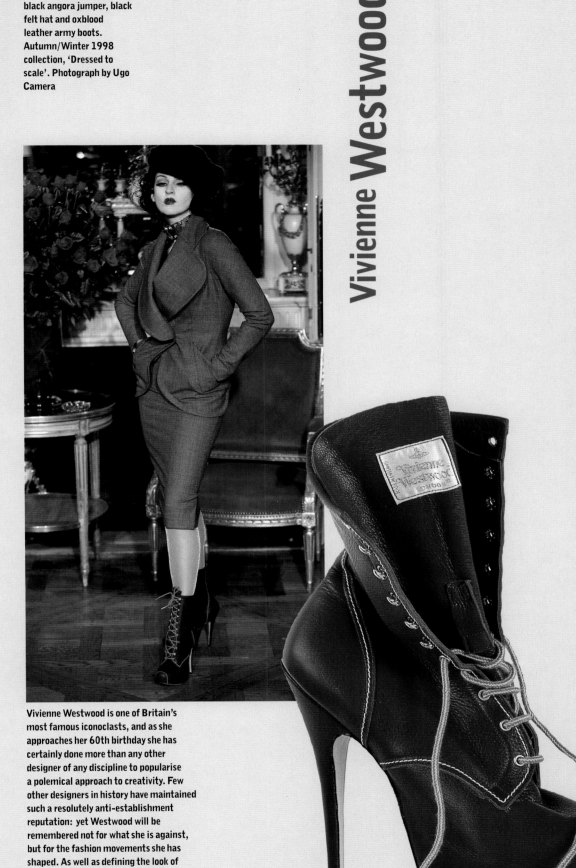

Grey tailored wool suit with black angora jumper, black felt hat and oxblood leather army boots. Autumn/Winter 1998 collection, 'Dressed to scale'. Photograph by Ugo Camera

Vivienne Westwood

Born in Derbyshire, Westwood started out as a teacher. Without formal fashion training, she began to design clothes and in 1971 she opened a shop 'Let it Rock' on London's Kings Road together with Malcolm McLaren. The collaboration was to last 13 years. By appropriating teddy boy styling and mixing it with patterns and fabrics more commonly associated with fetish-wear she created clothing that was wildly different from anything London had seen before. From these beginnings, Westwood went on to develop designs now seen as iconic in international fashion history: her punk bondage trousers, the 'cut and slash' look, the mini-crini, her fig leaf tights, infamously high platform shoes and padded busts and 'false bottoms'.

Today, Westwood heads a hugely successful fashion empire, and continues to innovate. Most recently, she has developed an approach which plays with the language of sophisticated haute couture. Her shows employ classical music, historically-inspired styling and an abundance of velvet. "With the whole punk thing, I realised that by attacking the establishment I'd become a victim; the only way to make a difference is through ideas, not rebellion," Westwood told the *London Fashion Book* in 1998. Nevertheless there is still a powerful streak of subversiveness running through her work. Although recent collections have explored apparently less radical themes, employing evening dresses, sumptuous bustles and hour-glass figures to create couture collections of surprising understatement, an underlying sense remains that Westwood, like Rei Kawakubo at Comme des Garçons, is really interested in subverting contemporary ideals of the female figure.

In 1991 she was voted Designer of the Year, and it is said that Westwood coveted the job of head designer at Christian Dior awarded to John Galliano. Perhaps age counted against her, but it is a racing certainty that history will judge Vivienne Westwood's work to have been every bit as influential as that of Galliano and the other hip young Brits.

Vivienne Westwood is one of Britain's most famous iconoclasts, and as she approaches her 60th birthday she has certainly done more than any other designer of any discipline to popularise a polemical approach to creativity. Few other designers in history have maintained such a resolutely anti-establishment reputation: yet Westwood will be remembered not for what she is against, but for the fashion movements she has shaped. As well as defining the look of the punks in the 1970s and the New Romantics in the early 1980s, Westwood took her designs to Paris in 1982 and helped pave the way for Galliano and McQueen a decade later.

CITY OF LONDON

LITTLE BRITAIN
EC1

Acknowledgements

The organisers would like to thank all those who have very generously lent work for the exhibition
Michael Anastassiades; Shin and Tomoko Azumi; Georg Baldele; BBC TV films; Birkenstock; Blatchfords Prosthetics; Mark Bond; Tord Boontje, Chris Storch of the Cornflake Shop; Counter Spy Shop; Tom Dixon; Tony Dunne and Fiona Raby; Eureka Video (clips from Fritz Lang Metropolis); Roberto Feo, Rosario Hurtado and Francisco Santos at El Ultimo Grito; Konstantin Grcic; Haldo Developments Ltd; Tim Brown at IDEO; Nick Crosbie at Inflate; Ross Lovegrove; Michael Marriott; Jasper Morrison; Will White and Katarina Barac at One Foot Taller; Vivienne Burt at Anti-Rom; Jonathan Barnbrook; Nick Bell; The Designers Republic; Paul Elliman; Miles Murray Sorrell Fuel; North; Veronica Sheppard at Pollocks Toy Museum; Mike Bennett of Sunbather at Razorfish; Michael Horsham and Graham Wood at Tomato; Lucien Treillard; Iain Cadby and David Ellis at Why Not Associates; Richard Wentworth; Wellcome Trust; Zowie Broach and Brian Kirby at Boudicca; Hussein Chalayan; Robert Cary-Williams; Desiree Mejer at Fake London; Shelley Fox; John Galliano; Owen Gaster; Alexander McQueen; Deborah Milner; Jessica Ogden; Vexed Generation; Vivienne Westwood.

Thanks are also due to many other people for their help in preparing the exhibition
Julia Ain-Krupa at Boudicca; Mesh Chidder at John Galliano; Janet Fischgrund at Alexander McQueen; Emma Greenhill at Hussein Chalayan; Maia Guarnaccia at Vivienne Westwood; Modus PR; Kate Monckton at Abnormal PR; Tank Magazine; Jude Tyrell at Science; Natalie Voran at Purple PR

Photographers
Quadrant Picture Library (Tony Hobbs, McDonnell Douglas Apache helicopter)
Barnaby and Scott (Fashion, in collaboration with Tank Magazine)
Nigel Jackson, David Spero, James Johnson, Martin Rose, Christine Sullivan

Translator
Felicity Lunn (translation into English of text by Volker Fischer)

The curators are grateful to the following for their advice and comments
Fiona Bradley, Claire Catterall, Diana Eggenschwiler, Paul Elliman, Liza Fior, Michel Jacques, Suzanne Lee, Rick Poynor, Jemima Pyne, Fiona Rattray, Elisabeth Scheder-Bieschin, Richard Wentworth.

The organisers would also like to thank the Visual Arts workshop team for their technical support.

All quotations from designers, unless otherwise attributed, are from conversations with the curators.

Select bibliography

Addressing the Century, 100 Years of Art
& Fashion Hayward Gallery Publishing,
London, 1998

Alison J & Farrelly L, **Jam. style + music + media**
Barbican Art Gallery + Booth-Clibborn
Editions, London, 1996

Barnbrook J, **Welcome to the Cult of the Virus**
London, 1997

Barthes R, **The Fashion System** Editions
du Seuil, Paris, 1967

Bruce Nauman Hayward Gallery Publishing,
London, 1998

Catterall C, **Powerhouse::UK** Aspen Publishing,
London, 1998

Cummings N (ed.), **Reading Things** SightWorks
VolumeThree, Chance Books, 1993

den Boer L, Strengholt G J & Velthoven W,
Website Graphics, the best of global site design
Thames & Hudson, London, 1997

Giovanetti R, **Oggetti Onesti, il volto maturo
degli oggetti autoprodott** Design File Edition,
Milan, Italy, 1998

Hall P & Bierut M (ed.), **Tibor Kalman**
Booth-Clibborn Editions, London, 1998

Heller S & Pomeroy K, **Design Literacy,
Understanding Graphic Design** Allworth Press,
NewYork, 1997

Hibbert C, **The Story of England** Phaidon,
London, 1992

Hyde K & Warwicker J, **mmm... skyscraper i love
you** Booth-Clibborn Editions, London, 1994

**Jasper Morrison, Designs, Projects and drawings
1981–1989** ADT Press, London, 1990

Keiller P, **Robinson in Space**
Reaktion Books, London, 1999

London College of Printing Prospectus 1998/99
London, 1998

London College of Printing Prospectus 1999/00
London, 1999

Lupton E & Miller J A, **Design, Writing, Research:
writing on graphic design** Princeton Architectural
Press, NewYork, 1996

Miles P, Murray D, Sorrell S, **Pure Fuel**
Booth-Clibborn Editions, London, 1997

Morrison J, **A Book of Spoons** Imschoot, Gent,
Belgium, 1997

Morrison J, **A World Without Words** Lars Müller
Publishers, Baden, Switzerland, 1998

**Oggetti Discreti, un viaggio nel mondo degli oggetti
d'autore anonimo** Fondazione Mudima, Milan,
Italy, 1997

Oliver P, Davis I & Bentley I, **Dunroamin;
the Suburban Semi and its Enemies** Pimlico,
London, 1994

Papanek V, **Design for the Real World** Human
Ecology and Social Change, (2nd edition)
Thames & Hudson, London, 1984

Perkins S, **Experience** Booth Clibborn Editions,
London, 1996

Poynor R, **Nigel Coates: The City in Motion**
Fourth Estate/Wordsearch, London, 1989

Poynor R, **Design Without Boundaries** Visual
Communication inTransition, Booth-Clibborn
Editions, London, 1998

Process; a Tomato Project
Thames & Hudson, London, 1996

Richard Wentworth's Thinking Aloud
Hayward Gallery Publishing, London, 1998

Sandberg J, **Arne Jacobsen og den OrganiskeForm**
Kunstforeningen København, Denmark, 1999

Slingsby Commercial and Industrial Equipment catalogue HC Slingsby plc, Bradford, 1998

Sobieszek R A, **Ports of Entry: William S. Burroughs and the Arts** Thames & Hudson, 1996

Taylor L, **Recycling (Forms for the Next Century – Austerity for Posterity)** Craftspace Touring, Birmingham, 1996

Tucker A, **The London Fashion Book** Thames & Hudson, London, 1998

van Toorn J (ed.), **Design beyond Design** Jan van Eyck Akademie Editions, Maastricht, Netherlands, 1998

Why Not Associates Booth Clibborn Editions, London 1998

Wiretapping and electronic surveillance Commission Studies, Loompanics Unlimited, Port Townsend, USA, 1983

Index of designers

Catalogue of the exhibition 'Lost and Found: critical voices in new British design'
Curators: Nick Barley, Stephen Coates, Marcus Field, Caroline Roux
Exhibition designers: muf

A CIP catalogue record for this book is available from the Library of Congress, Washington D.C., USA.

Die Deutsche Bibliothek – CIP-Einheitsaufnahme

Lost and found : critical voices in new British design / British Council. Nick Barley. – Basel ; Boston ; Berlin : Birkhäuser, 1999
Dt. Ausg. u.d.T.: Lost and found, - Franz Ausg. u.d.T.: Lost and found
ISBN 3-7643-6095-X (Basel ...)
ISBN 0-8176-6095-X (Boston)

©1999 The British Council,
11 Portland Place, London W1N 4EJ, Great Britain; Birkhäuser – Publishers for Architecture, P.O. Box 133, CH-4010 Basel, Switzerland.
This book is also available in German (ISBN 3-7643-5998-6) and in French (ISBN 3-7643-6096-8).
Printed on acid-free paper produced of chlorine-free pulp. TCF∞
Printed in Italy
ISBN 3-7643-6095-X
ISBN 0-8176-6095-X

987654321

Design: Anne Odling-Smee, Stephen Coates
Editing: Nick Barley, Caroline Douglas, Jessica Lack, Alex Stetter
Research: Hannah Ford, Suzanne Lee, Alex Stetter, Sophie Taylor
Front cover photograph: Martin Rose